DIGITAL COMPACT CAMERAS

Arnold Wilson

DIGITAL COMPACT CAMERAS

Arnold Wilson

GUILD OF MASTER CRAFTSMAN PUBLICATIONS

First published 2008 by

Photographers' Institute Press / PIP

an imprint of The Guild of Master Craftsman Publications Ltd,

166 High Street, Lewes, East Sussex BN7 1XU

ISBN 978-1-86108-527-6

British Cataloguing in Publication Data. A catalogue record of this book is available from the
British Library.

Production Manager: Jim Bulley

Managing Editor: Gerrie Purcell

Project Editor: Rachel Netherwood

Managing Art Editor: Gilda Pacitti

Designer: James Hollywell

Colour reproduction by GMC Reprographics

Printed and bound in China by Colorprint Offset

CONTENTS

INTRODUCTION

THE DIGITAL CAMERA revolution has already taken place as new models are released almost monthly. As the number sold has increased, costs have fallen dramatically with current prices less than half what they were two to three years ago.

The reasons for the enormous uptake of compact digital cameras by all sections and ages of the population are not difficult to discover. The main reason is that the highly sophisticated microprocessors, built into even the smallest, cheapest camera, allow anyone with virtually no knowledge of photography to take decent photographs over a wide range of subjects.

Another reason for their popularity is that shots can be taken and examined immediately, with the unwanted ones erased at the touch of a button (or two!).

Using digital you don't have to wait for the results to be processed and printed in a photo lab. Most inexpensive printers will accept the memory card or the camera, allowing prints to be made instantly. Using a computer, images can be manipulated and improved in dozens of ways and then printed out. Finally, you do not have the expense of buying 'use once' films. The memory card can be used and reused many times.

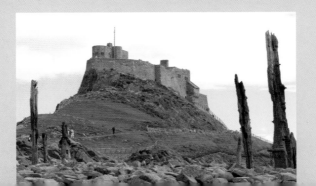

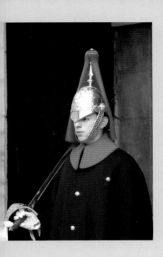

The disadvantages of the digital compact camera are few. The zoom range on digital compacts is at the moment rather limited; 35–110mm is the norm, although this is gradually improving, particularly at the telephoto end. Also, these sophisticated cameras are energy hungry, requiring a spare set of charged batteries to be carried at all times. Some people are quite concerned as to whether, in say ten years' time, computers will be able to accept the image data of today.

The aim of this book is threefold: first, to overcome the natural apprehension in someone who is new to photography (or has recently moved from film) and is now confronted by a highly sophisticated piece of electronic equipment featuring a seemingly endless array of buttons, dials and menus.

Second, to describe and explain the basic workings of the camera, commencing with the lens, diaphragm, shutter and image sensor and gradually introduce the rest of the major controls, outlining their uses in everyday picture making.

Third, to encourage and help you, the camera owner, to produce well-composed, interesting photographs across a wide range of subjects, bearing in mind that today's digital compact camera can now produce results of a quality unthinkable just a few years ago.

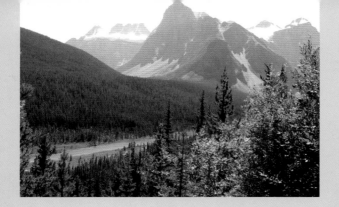

The book is in two parts; Part one, Basics, covers the fundamentals of the camera while Part two, Out and About, deals with a whole range of photographic activities.

Part one begins with an explanation of how the camera works, leading to a discussion on controlling and using the camera. A range of accessories is considered followed by an important section on composition and framing the image. Understanding the principles of composition is fundamental to achieving captivating photographs. There is also a useful introduction to choosing a camera and part one concludes with a chapter on post-shot procedures. These include making prints from stand-alone printer/scanners, transferring images to the computer, and some basic information on manipulation of the images on the computer screen.

Part two covers a wide range of photographic activities that can be tackled using a digital compact camera. Landscape photography is covered in some detail, with plenty of advice and suggestions on how to take appealing photographs.

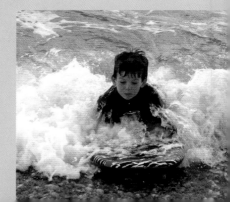

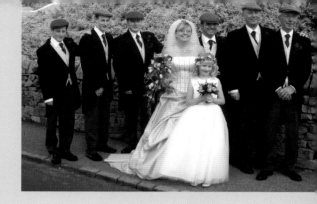

Most digital compacts can now focus down to a few centimetres, allowing excellent close-ups to be taken. This is covered in the chapters on nature photography and still-life.

Portrait photography is included, concentrating on taking pictures using only daylight and household reading and standard lamps. Outdoor portraiture is also discussed. No book would be complete without a section on pets, and includes not only cats and dogs, but fish, hamsters, gerbils and guinea pigs.

Probably the most popular use of the digital compact camera is in holiday photography. The ideal holiday camera is discussed, along with suggestions on how to capture more interesting holiday shots in addition to the standard, but none-the-less important, family snapshots.

In this book I have included pictures taken with a variety of compact digital cameras from manufacturers including Casio, Vivitar, Nikon, Panasonic and several models from Canon – all capable of producing excellent photographs in a wide range of situations with the minimum of fuss.

BASICS

HOW THE CAMERA WORKS

RATHER SURPRISINGLY, THE basic fundamentals of photography have not really changed since the Frenchman Louis Daguerre, in 1839, produced a positive image from mercury vapour on a polished coating of light-sensitive silver iodide. Then, as now, we need a light-proof box with a lens, diaphragm, shutter and a light-sensitive surface at the back of the box.

The lens The function of the lens is to collect the light and focus it on the light-sensitive surface at the back of the camera. Lenses are computer-designed, multi-element units, manufactured in glass or plastic with most of the elements being symmetrical and 'spheric' (part of a sphere). One or two elements are asymmetrical (not part of a sphere) and are referred to as 'aspheric'. Lenses are not cheap; the highest quality 600mm f/4 telephoto lens for a Nikon SLR camera costs over £7,000 ($14,000)!

The focal length of the lens is the distance between the lens and the image sensor when the lens is focused on distant objects. The focal length of a standard lens on a 35mm film camera is usually 50mm. But to produce the same size image on the image sensor in a digital compact, the focal length would be about 8–9mm. Most digital cameras have a zoom lens, enabling the user to produce a larger image from the same distance. My Canon A700 has a zoom range of 5.8–34.8mm (the 35mm equivalent is 35–210mm), which is a 6x optical zoom.

Diaphragm Around the rim of a zoom lens surround there will be two sets
and f-numbers of figures, such as 5.8–34.8mm and 1: 2.8–4.8. The first set of figures indicates the range of focal lengths available, in this case 5.8–34.8mm (a 6x optical zoom). The second group of figures (ignoring the figure 1) represent the f-number or 'speed' of the lens, for example f/2.8 at the wideangle setting and f/4.8 at the telephoto end. But what do these numbers mean?

An adjustable iris diaphragm, consisting of pivoted blades, is located between the lens elements, usually next to the shutter mechanism. Its function is to control the amount of light passing through the lens and, together with the shutter, set the exposure generated by the light meter. The speed of the lens is based on the area of the glass elements and its focal length; by international agreement the starting point is f/1. At this setting the effective diameter of the lens aperture is equal to the focal length of the lens. Each time the diaphragm is closed down a little and the light transmitted halved, a new f-number emerges. The complete sequence is f/1, f/1.4, f/2, f/2.8, f/4.5, f/5.6, f/8, f/11, f/16, f/22, f/32 and so on. Each f-number increase transmits half as much light as the previous f-number. Therefore f/1.4 and f/2 are referred to as 'fast' lenses, which let in a lot of light, while f/11 and f/16 are 'slow' lenses, transmitting 1/64th of the light level of the fast lens settings mentioned above.

Stopping down the lens increases the depth of field (how much of the image is acceptably sharp in front of and behind the point of focus). This is particularly important in landscape photography where most photographers prefer everything from nearby to infinity to be in sharp focus. The downside is that longer exposures are required, hence the popularity of tripods in landscape photography.

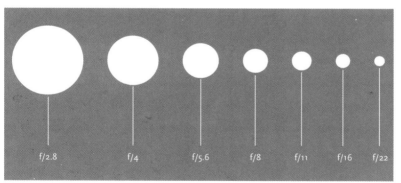

f/2.8 f/4 f/5.6 f/8 f/11 f/16 f/22

The diagram illustrates how the size of the lens aperture decreases as the f-number increases. Each increase in f-number halves the amount of light passing through the lens.

Focal length and field of view How the subject appears in the final image depends on the setting (the focal length) of the zoom lens. A wideangle setting produces an expanded field of view which is ideal for panoramic shots, while the telephoto end delivers a magnified image but a very narrow field of view. The focal length (or zoom setting) affects the depth of field: the shorter the focal length, the greater the depth of field, which is why many landscape photographers use the wideangle zoom setting. The converse is also true: a longer focal length (a telephoto zoom setting) compresses the scene and appears to reduce the depth of field. The following five images illustrate the effect of setting the lens at different focal lengths.

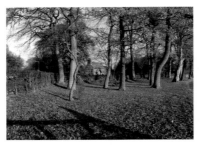

ZOOM LENS (6x) WIDEANGLE, plus a wideangle converter; 25mm focal length.

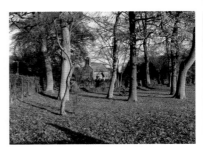

STANDARD WIDEANGLE; 35mm focal length.

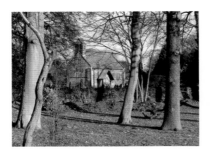

MID-ZOOM SETTING; approximately 100mm focal length.

FULL ZOOM; 210mm focal length.

The camera shutter (and lens aperture) controls the amount of light reaching the image sensor at the back of the camera. All compact digital cameras have a 'between-the-lens' leaf-blade shutter. This consists of pivoted metal blades which open and close for a set period of time when the shutter-release button is pressed, allowing the light to reach the image sensor. Most shutters are electronically controlled with speeds ranging typically from 15 sec to 1/1500 sec. The advantage of this type of shutter is that it can be flash-synchronized at all speeds, because at some point in the shutter cycle the blades are fully open. The downside is that cameras with interchangeable lenses would require a shutter built into each lens, making them very expensive.

Why do we need a range of shutter speeds? At the extremes, a racing car driven at speed or an ice-hockey player in action would require a very short exposure of 1/500–1/1000 sec to prevent the image being very blurred. An evening shot or a night scene would require a long exposure of several seconds. If your camera allows you to set the shutter speed or the aperture, then there's no problem; if it won't then you will have to rely on the scene settings available and let the camera, in its infinite wisdom, decide for you.

The five images shown on the next pages illustrate the effect of using different shutter speeds. Apart from the final image (with handheld swung camera), all shots were taken using a tripod-mounted camera, rendering the background sharp.

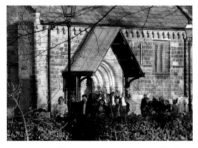

FULL ZOOM, plus 2x converter; 420mm focal length.

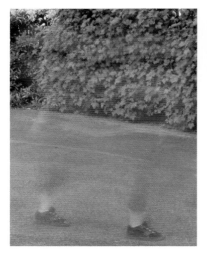

1 sec: a complete blur with only the shoes visible.

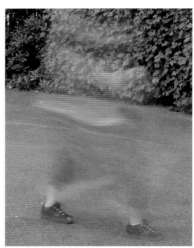

1/2 sec: still a blur.

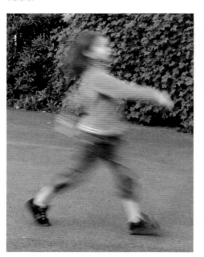

1/40 sec: blurred but figure is just discernible.

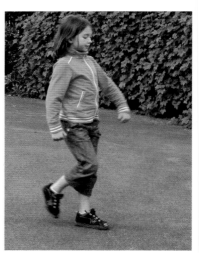

1/200 sec: sharp figure.

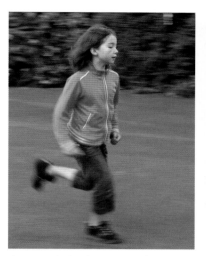

1/40 SEC: swinging the camera results in a sharp figure (except extremities) and a nicely blurred background.

Multizone (or evaluative) metering is ideal for this type of shot with mixed colours across the entire screen.
APERTURE PRIORITY 1/300 SEC, F/6.3, ISO 100.

Exposure meters

All modern cameras have an integral exposure system. In order to produce 'better' exposures, more sophisticated systems have been developed, including the original centre-weighted metering with approximately 60 per cent of the final reading taken from the central area, where it is assumed that the main subject lies. Many cameras also have spot metering, in which a central spot, representing about 2 per cent of the total image area, is selected for exposure assessment. In multizone metering, light values are measured in segments of the image field with the camera computing the readings to produce the 'best' exposure – effective in difficult lighting conditions. All exposure meters are calibrated to produce the 'correct' exposure on the assumption that the subject is reflecting 18 per cent of the light falling on it. When the subject reflects less than 18 per cent – for example, in the classic case of a black cat in a coal cellar – the meter will indicate a longer exposure, with the black cat registering grey. Similarly snow or white blossom will be underexposed, appearing greyish in the final image.

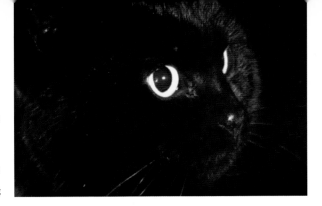

The camera's exposure meter would suggest a long exposure, rendering the black cat an insipid grey. The exposure was reduced by two stops and I used two sidelights to highlight the cat's fur, separating it from the dark background.
APERTURE PRIORITY
1/60 SEC, F/11,
ISO 80.

Many years ago Kodak marketed a grey card (still available today) which produced 18 per cent reflectance. When held in front of the camera to almost fill the field of view, an accurate reading would be obtained, with snow registering white and black cats, black. All the metering systems discussed so far measure the light reflected from the subject. An alternative method is to measure the light falling on the subject. This is incident light measurement, whose value is not subject to the colours and tones of the subject being photographed; however, it is of limited interest to the digital compact camera user.

Shooting modes
Most digital compact camera owners select auto or programme mode to determine the exposure. These modes automatically select exposures based on a combination of lens apertures and shutter speeds. Many digital compacts also have aperture priority settings where the photographer selects the aperture (and therefore the depth of field), leaving the camera's exposure meter to determine the shutter speed. In shutter priority the photographer selects the shutter speed and the camera's metering system selects the correct aperture. Shutter priority is useful when photographing moving subjects such as people, cars, birds or animals.

Image sensor
The majority of digital cameras use a CCD (charge-coupled device) or a CMOS (complementary metal oxide semiconductor) image sensor. A typical compact digital camera might well have a 1/2.5in sensor (these imperial units date back to an early system used in TV cameras). A 1/2.5in sensor measures 5.8 x 4.3mm and can incorporate up to 10 million pixels.

The pixels are arranged in a regular mosaic, each responding to light and generating a tiny electrical charge. Each pixel is covered with either a red, green or blue filter (the same three colours which make up a TV picture) with twice as many greens to correspond to the human eye's greater sensitivity to green light.

The raw data is handled by the camera's processor and passed on to the memory card. To keep the file size small and allow more images to be stored on the memory card, the image information is compressed into a JPEG (Joint Photographic Expert's Group) file. The camera's processor removes areas of similar colours and detail in the image. When the file is opened again most of the missing information is replaced, increasing the file to its original size. JPEGs come in varying degrees of compression, with the least compressed producing the highest quality images. Images not processed in-camera are RAW files, which take up more storage space.

What is an ISO setting and how relevant is it to picture making? The sensitivity of the image sensor to light is referred to as its speed or ISO (International Standards Organization) rating. At a low setting (such as ISO 80) the sensor has reduced sensitivity to light but produces a clear, detailed image, whereas a high ISO setting has the opposite effect. Doubling the ISO number doubles the sensor's sensitivity to light – the equivalent of an increase of one f-number or halving the shutter speed. Low ISO settings are ideal for showing fine detail and are therefore excellent when photographing landscapes, portraits and slow-moving subjects.

Image sensor sensitivity

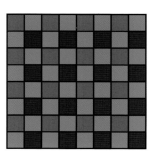

The CCD image sensor in a typical compact digital camera is tiny, measuring around 5.8mm x 4.3mm. It contains up to 6 million red, green and blue light-sensitive pixels. The most common type of colour filter is the Bayer pattern mosaic, shown here.

Using a low ISO setting produces a smooth, clean image full of detail, but the sensitivity to light is low.
APERTURE PRIORITY 1/13 SEC, F/8, ISO 80, TRIPOD-MOUNTED CAMERA.

A high ISO setting allows the use of a much faster shutter speed – ideal for all sporting activities or when working in poor light. The downside is an increase in noise.
SHUTTER PRIORITY 1/350 SEC, F/4.5, ISO 400.

High ISO settings allow shorter exposures, which are ideal for fast-moving action. High ISO settings can also be used when shooting in low light conditions such as night scenes. The downside is that high ISO settings not only amplify the electrical signals from the sensor, but also introduce noise (non-signal impulses), resulting in graininess and lack of detail, particularly in areas of dark tone. I always try to use the lowest ISO setting possible.

Megapixels and size

It is useful to know how many pixels are required to produce an acceptably sharp photograph. A rough guide is 2–3 megapixels (mp) for a 6 x 4in (15 x 10cm) print; 3–4mp for 7 x 5in (18 x 13cm), 5mp for A4 and 6+mp for A3 prints. However, I have produced excellent A4 enlargements from a 4 megapixel Canon IXUS 40 compact camera. Using a 1/2.5in sensor (5.8 x 4.3mm) anything beyond 6mp tends to produce more digital noise, with the overall gains being minimal.

After the photograph has been taken, the electronic information from the image sensor is transferred via the camera's processor into the camera's memory. On most digital compacts the built-in memory is between 10 and 32MB. Extra memory is available in the form of compact memory cards. The higher-priced cards (for the same storage capacity) have a better quality flash memory chip, so will probably last longer and be less likely to lose data. They also allow more pictures to be taken more quickly, with less time lag between pressing the shutter button and the information being processed to the memory card.

Memory card

On a compact digital camera the image is viewed on a liquid crystal display (LCD) screen at the back of the camera. It contains 65,000–230,000 pixels; the picture coverage is around 100 per cent. It is easy to use, except in bright sunlight with the sun behind you, when it can go completely black. Some manufacturers have developed effective screen shades (see page 35).

Viewing the image

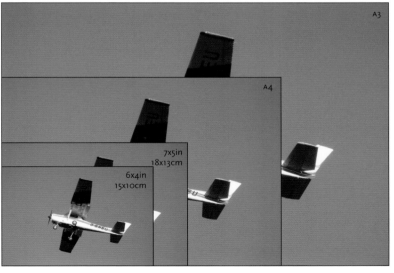

The chart shows the minimum recommended number of megapixels required to produce high film-quality enlargements. This is not absolute; other factors, both mechanical and electronic, can affect image quality.

CONTROLLING THE CAMERA

2

Fortunately the majority of digital compacts share many common features and so the various switches, dials and buttons described here should apply – in principle, at least – to your camera. You might find all its functions daunting, but at the end of this chapter is a section called 'Getting started', which is a basic approach to taking your first photographs. Become familiar with that and you can add the more complex functions later.

Camera front LENS

This is the key element in any camera, directing the light onto the image sensor at the back of the camera. It has built-in automatic focusing (and sometimes manual focusing), an adjustable iris diaphragm (lens f-number), which controls the light entering the camera, and a zoom facility to produce enlarged images.

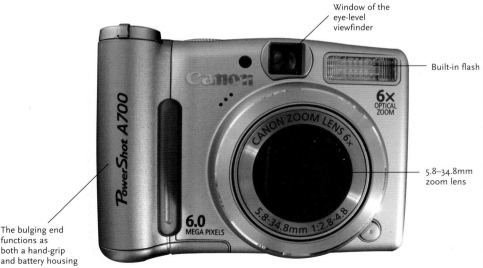

Window of the eye-level viewfinder

Built-in flash

5.8–34.8mm zoom lens

The bulging end functions as both a hand-grip and battery housing

AUTOFOCUS (AF) ASSIST
In dim light it produces a red beam of light which helps the camera to focus on the subject.

FLASH WINDOW
The built-in flash unit is controlled by a button on the back of the camera. It has a fairly weak output – its guide number is around 11 at ISO 100 (see box, below, for more on guide numbers).

OPTICAL VIEWFINDER
This is only found on some digital compact cameras but is useful for viewing the image in bright sunlight when the LCD screen image is difficult to see.

> • **Guide numbers (GN)**
> The flash guide number (GN) is the product of the lens aperture (f-number) and the distance from the flash unit to the subject at the ISO 100 setting. A GN of 11 means that the maxiumum shooting distance to obtain a correctly exposed image with the lens set at f/4 is 2.75m (11/4).

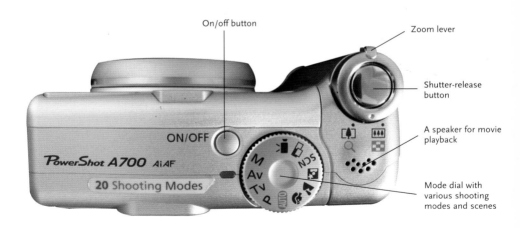

On/off button

Zoom lever

Shutter-release button

A speaker for movie playback

Mode dial with various shooting modes and scenes

Camera top POWER SWITCH
This switch turns the camera on and off.

SHUTTER-RELEASE BUTTON
This operates the shutter, allowing a measured amount of light to
fall on the image sensor. Half pressing the button activates the
autofocus mechanism and the light meter to make an exposure,
which shortens the shutter delay time. The shutter-release button is
often surrounded by a spring lever which activates the optical zoom
lens, although on some cameras the zoom control is a separate
switch. The digital zoom is operated from the same lever.

Shooting The shooting mode dial is usually located on the top of the camera.
mode dial On higher specification cameras it includes AUTO, P, A, S, M and
scene settings.

AUTOMATIC (A)
In this mode the camera controls everything; you simply point and
shoot. However, you will produce better photographs when you
start using the other settings.

PROGRAMME (P)
This mode, which I recommend if the camera has no aperture or
shutter priority setting, allows the photographer control over ISO
settings, metering, exposure compensation and so on, although the
shutter and lens aperture settings are looked after automatically.

APERTURE PRIORITY/SHUTTER PRIORITY (A/S)
In aperture priority mode (A) you select the most appropriate
aperture: a wide aperture for portraits, to throw the background out
of focus; or a narrow aperture for landscapes, to obtain maximum
depth of field. Having set the aperture, the camera's exposure
meter selects the appropriate shutter speed. In shutter priority
mode (S – or TV on some cameras) you select an appropriate
shutter speed. Use a fast shutter speed for fast-moving action, or
a slow shutter speed for landscapes with a tripod-mounted camera.

MANUAL (M)

In this mode you select the aperture and the shutter speed independently of each other. The camera should indicate how many stops you have chosen above or below the 'correct' exposure. This setting is used mainly by experienced photographers when producing, for example, high- or low-key portraits.

LANDSCAPE, PORTRAIT AND NIGHT SCENES

These settings are usually included on the shooting mode dial. In landscapes, the lens is stopped down to increase the depth of field; in the portrait setting the lens is kept open to blur the background. A night scene mode allows you to capture a subject against an evening sky or night scene. The flash is directed at the subject, with a slow shutter speed, ensuring the background is adequately lit.

SPECIAL SCENES (SCN)

There are often over 20 scene settings. A snow setting, for example, removes the blue tinge and lightens what would otherwise be light grey snow; a kids and pets mode selects a short shutter speed appropriate to photographing quick-moving subjects. A fireworks setting gives a long exposure at a narrow aperture.

STITCH ASSIST

This lets you shoot overlapping images which can later be merged (stitched), using a computer, to create a long panoramic picture.

MOVIE MODE

You can record short movie sequences, often with sound, on most digital compact cameras. The default setting is for standard movies recording at 30 frames/sec, although faster frame rates (up to 60 frames/sec) and slower frame rates (15 frames/sec) are normally available. The fast frame rate is suitable for filming sports or any fast-moving action, producing a smooth moving image. Each sequence usually lasts from one to three minutes, depending on the frame rate used; a 512MB memory card can store up to 25 minutes of the highest quality footage.

Camera back LCD (LIQUID CRYSTAL DISPLAY) SCREEN

The largest component on the camera back is the LCD screen, which shows the image you are about to photograph. Screen sizes range from 2in (5cm) to 2¹/₂in (6cm).

FOUR-WAY BUTTON

One switch often controls the flash unit (on, off, auto) while another sets the close-up and manual focusing (MF) options.

FUNCTION BUTTON (FUNC SET)

The function button usually provides information on a whole range of settings including ISO, white balance, drive, flash compensation, metering, compression, image quality and image size. Each is on a default setting, but can be altered. For example, the ISO setting can be changed from auto to fixed values (80–800), while the evaluative metering can be altered to centre-weighted or spot. Image quality depends on the degree of compression. As compression increases, more information is removed, reducing the overall quality of the image. There are usually three or four compression settings including Superfine, Fine and Normal.

The image size (recorded pixels) is usually designated as large (L), medium (M) and small (S), indicating the size of reasonable quality prints you can expect at each setting. As the size is reduced, so too is the number of active pixels involved.

- **Tip**
Compressing images and reducing image size speed up the processing in the camera. I always set my camera to superfine (S) compression and large (L) picture setting, thereby ensuring that, regardless of print size, the images will always be of the highest quality.

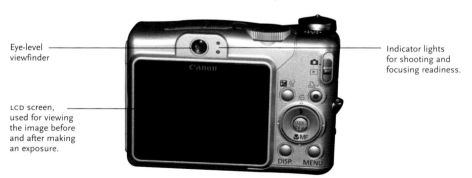

Eye-level viewfinder

Indicator lights for shooting and focusing readiness.

LCD screen, used for viewing the image before and after making an exposure.

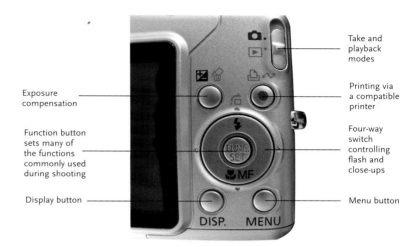

Exposure compensation

Function button sets many of the functions commonly used during shooting

Display button

Take and playback modes

Printing via a compatible printer

Four-way switch controlling flash and close-ups

Menu button

MENU BUTTON

The menu setting provides up to three 'pages' of set-up information, much of which you can leave on the default settings. These include red-eye, AF assist beam, digital zoom, mute, volume, start-up sound, shutter sound and so on.

DISPLAY BUTTON (DISP)

This button shows the current settings for ISO, metering, flash mode, exposure compensation, picture size and compression.

EXPOSURE COMPENSATION BUTTON

This button allows you to alter the exposure, particularly after examining the shot just taken, and then re-shoot the scene.

TWO-WAY SWITCH

This looks after shooting the picture and reviewing the image later. Finally, there are two coloured indicator lights next to the viewfinder eyepiece (if fitted) with the green light, either steady or blinking, providing information about the camera's readiness for action, while the orange light indicates the current status of the flash unit (steady = flash ready; blinking = flash charging).

Playback mode Switching from Record to Playback brings up the image on the LCD screen, while activating the zoom lever enlarges it allowing closer inspection for overall quality and definition. The display (DISP) button shows the shooting parameters on the screen including the ISO setting, exposure, file size and exposure compensation, plus a histogram indicating whether the image has been correctly exposed.

Pressing the MENU button displays features such as auto-play, image rotation, image erasure and sound memo. To erase an image two buttons must always be pressed; the dustbin button provides a choice of 'erase' or 'cancel', while pressing the function button completes the procedure.

Camera base The rechargeable battery, either the popular AA size nickel metal hydride (NiMH), or the more compact lithium-ion (Li-ion), plus the memory card, are located in the camera base. The Li-ion battery comes supplied with a mains charger but the charger for the AA batteries must be bought separately.

The other important fitment is the tripod socket, with a thread pitch and screw depth that is universal, allowing any tripod head, or ball and socket, to be screwed into it. However, not all cameras will have this feature.

Camera side There are three sockets, usually grouped together and protected by a plastic cover. The first is the Audio/Video (A/V) outlet, which provides playback of images on the TV screen, using the A/V cable supplied. The second socket is the digital terminal, which connects the camera to a computer via the supplied interface cable. With the power on and the camera set to playback, it can communicate with the computer, allowing information to be downloaded into the computer. The third socket is the DC terminal, which connects a low voltage power supply to the camera. It is very useful when using the camera for long periods, such as when examining recorded images or when it is connected to the computer. The adapter is not part of the camera package.

To help you get started I would suggest using programme mode, leaving the variables such as white balance, drive mode, compression and picture size in the default mode. I would, however, set the auto ISO setting to ISO 100–200 to ensure smooth, noise-free, detailed images.

When you are familiar with programme mode, try using other modes such as portrait, landscape and some of the special scene settings, many of which will help you to produce better pictures.

Finally, when you have got to grips with depth of field and different shutter speeds, move on to the aperture/shutter priority mode and you will start to take even more inspiring photographs.

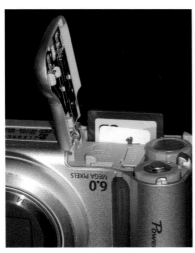

This camera base contains a tripod socket at one end. At the other end, two AA rechargeable batteries and the SD memory card lie concealed under a plastic flap.

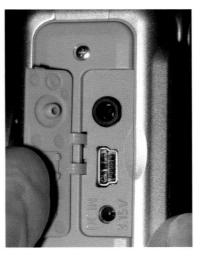

The following features are located under a sprung flap on the end of the camera. At the top, a miniature jack socket to connect the camera to a TV for playback of the images. In the centre is a miniature USB socket to connect the camera to a computer. The bottom socket allows the camera to be powered externally using a small mains-powered low voltage unit.

USEFUL ACCESSORIES

..

3

A GENUINELY ENTHUSIASTIC photographer sporting a large digital SLR camera will no doubt have a sizable bag full of extra lenses and a host of accessories, plus, of course, a heavy, bulky tripod. The whole point of owning and using a compact digital camera is that it can be easily carried in your pocket, along with any accessories.

The camera will require a protective pouch or case, which does not normally come with the camera. Smooth leather pouches are neat and compact but offer too little protection, while the larger padded ones protect well but are rather bulky.

A couple of spare memory cards and a set of charged batteries are worth carrying, enabling you to take several hundred images without any storage or battery problems. I use 512MB cards, which have good storage capacity but are not too expensive.

To view the LCD screen we tend to hold the camera at almost arm's length. This unstable, cantilever-like position produces camera shake, particularly at the telephoto end of the zoom range.

A handheld camera can be given extra stability by simply supporting your arm on your knee, or against the side of a building or tree.

A clamp tripod is a versatile, pocketable accessory. It can be attached to any convenient structure, affording excellent support. Some models feature a set of mini tripod legs and a wood screw.

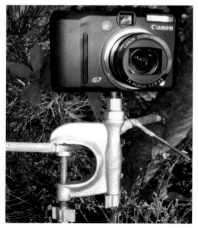

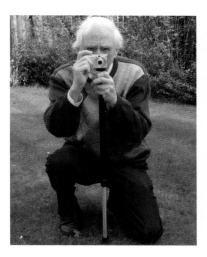

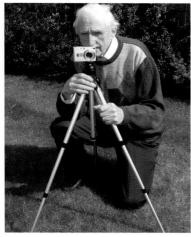

A monopod is light and easy to carry. Supported by arms and legs it can produce quite a firm support.

Tripods are the ideal method for supporting the camera but they tend to be rather bulky if you want to travel light.

Camera supports

Fortunately some manufacturers are beginning to incorporate image stability technology into their cameras. However, if your camera does not have this feature, try the following methods.

Resting the camera on a beanbag, placed on the car roof or on a wall, is an effective solution, as is simply supporting your arm on your knee or against a building. A small clamp tripod is useful and will fit into a pocket (see opposite). Also pocket-sized is the bendy-legged Gorillapod – a tripod made up of ball-and-socket joints.

Monopods give extra stability to a handheld camera when photographing birds in flight or animals on the move. A monopod and your own two legs form a useful human tripod. For serious photographic work it is worth carrying a light tripod. I use a Manfrotto unit which measures 18in (46cm) when closed, extending to 63in (160cm). It has a ball-and-socket head which I find more compact and useful than a pan-and-tilt unit.

Whatever method you choose, supporting the camera efficiently is essential if you are to avoid camera shake. Also try to ensure the exposure is no longer than the reciprocal of the focal length of the lens. For example, if your lens has a 6x zoom, then at full zoom (approx. 210mm) the exposure should be no longer than 1/210 sec.

There is no cable release socket on a digital compact camera, but this adjustable accessory allows one to be used, as the cable plunger simply presses on the shutter-release button.

Shutter-release systems

There is little point in setting up the camera firmly and then prodding the shutter-release button with an extended finger. Although digital compact shutter buttons are not threaded to take a cable release, adapter brackets are readily available and these work quite well. Some camera shutters can be triggered using an infra-red remote control unit. The built-in self-timer can be called upon if the subject is static.

Reflectors and diffusers

Reflectors are used to lighten the dark shadows on very sunny days. They vary in their reflective power: a mirror is a 100 per cent reflector which functions almost as a second main light; crinkled aluminium cooking-foil produces a more diffused light. A plain white surface is a much weaker reflector, delivering very soft diffused lighting. I collect small reflectors from odd sources, including lids from Chinese take-away containers (white and silver), circular cake bases (crinkled silver and gold) and bathroom cabinet mirrors. You can of course buy professionally made white, silver and gold reflectors. Some versions collapse to 6in (15cm).

Diffusers soften the light source. When photographing close-up work in bright, harsh sunlight, I often stretch a white handkerchief between the sun and the subject to soften the lighting and reduce the contrast. Flash lighting can produce hard-edged shadows and a handkerchief tied over the flash head will soften the light considerably, but this will absorb at least one stop in the process.

Digital compact cameras are not designed to take filters, but it is easy to hold them in front of the lens. The lens is fairly small, while the filters are quite large (particularly square Cokins).

I have a set of filters but I only take one or two that will be appropriate to whatever subject I hope to photograph that day. A polarizing filter will cut out surface reflections and increase the colour saturation of grass and blue sky, while an amber warm-up filter (81A and 81C) will brighten up a cold scene. I also use a neutral density graduated filter to darken an overlit sky and, if at a high altitude, an ultraviolet (UV) filter to reduce the ultraviolet light so prevalent in mountainous regions. A graduated sunset filter is popular with some photographers as it heightens the colours in a sunset scene. Finally, a starburst filter can be used to enhance point sources of light such as street lights and outdoor evening festivities.

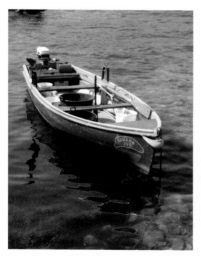 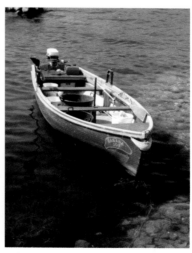

Without a polarizing filter there are lots of reflections from the surface of the lake.

With a polarizer the reflections are reduced and the underwater weeds become more visible as the light penetrates the water.

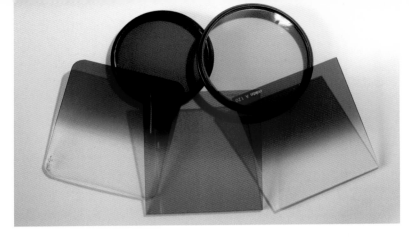

A selection of useful filters, which can be held over the lens, include an 81c warm-up filter, a polarizer, a graduated blue filter, a sunset filter and a graduated neutral density filter.

Flash units Digital compacts have a small built-in flash (guide number about 8–11 at ISO 100), but do not have an accessory shoe or even a PC (power cord) socket. However, all is not completely lost, because it is possible to use an external slave flash unit with either a built-in sensor or a separate sensor linked to the flash unit via a PC cord. The flash from the camera triggers the slave flash, although the exposure may need adjusting after the initial image has been examined. The slave flash may not work when photographing outdoors where reflections from the camera's flash may be practically non-existent, unless the separate sensor unit is almost facing the camera's built-in flash unit. I have used Olympus and Metz flash units with a PC cord and sensor with great success, particularly as a side- or backlight.

Several digital compact camera manufacturers have designed small matching slave flash units which can be attached to the side of the camera and are triggered by the camera's flash. They can also be used remotely as a side or back light. The independent manufacturer Kenro markets a small slave flash unit which can be triggered by a flash from any camera.

All compact digital cameras include a slow sync flash mode (night setting) – the flash fires while the aperture and shutter speed are kept as if the flash were switched off. This is particularly useful in night scenes where the longer exposure will capture some of the background detail, while the flash illuminates the subject.

Using the LCD screen in bright sunlight can be very difficult (it may even go completely black), but the problem has been partially solved by using a screen shade. When open it provides easier viewing of the screen, and when closed it helps to protect the screen. These shades are available in various screen sizes from 1.6 to 2.5in (4 to 6.3cm). However, a slight disadvantage with them is that if your camera is a snug fit in its case, the extra thickness may be just too much for it and a new case may be required.

Although digital compact cameras are extremely versatile instruments they do lack an extended zoom range, with a 3x optical zoom of usually 35–105mm (35mm film equivalent) being the norm. However, this can be usefully extended by adding a wideangle converter to the short end and a tele-converter to the long end, giving a more useful range of around 25–170mm (35mm film equivalent). These are well worth having if you need this extra facility for your wideangle or telephoto work. Optical performance is good but not perfect.

Adding together all the accessories described in this chapter would need a fair-sized bag. However, most photo-excursions require only a small selection of these accessories. For example, your holiday baggage might include the camera, a small camera clamp tripod and one or two filters; in other situations, such as photographing a carnival, the camera alone will suffice.

LCD screen shades

A selection of remote slave flash units, which can be used with any digital compact camera. The two at the front (left and middle) have built-in sensors. The other two units have a sensor attached via a PC cord.

COMPOSITION

..

4

COMPOSITION REFERS TO the way we visually arrange the various components of the subject to form a harmonious whole. The final image might be dramatic, moody, pastoral or even jarring, but if you are happy with the arrangement, then for you, the composition is satisfactory. Composition can be very personal, but for your work to be accepted by a wider audience, then to some degree you should compose the image within universally held guidelines.

Most people can recognize a 'good' or 'pleasing' picture without being able to say precisely what makes it good or pleasing. For some, good composition is instinctive and second nature, but for others it has to be explained and thought through before the concept becomes understood.

Analyse the paintings of Rembrandt, Turner and Monet, the photographs of Karsh, Cartier-Bresson and Lichfield, or the wildlife images of Stephen Dalton, John Shaw and Laurie Campbell and you will discover that they have all been very carefully composed, often along well-established lines. The 'rules' of composition are not meant to suppress your own creativity, but merely a guide, to help you develop your own style. A successful picture is a combination of technical skills, which can easily be mastered, and your aesthetic awareness, which puts your own individual stamp on the image.

Selecting the subject Although this might seem obvious, many photographers don't think about the subject before pressing the shutter-release button. For example, are you trying to photograph the dog in the garden, the dog *and* the garden, or simply the dog? Your answer will determine what zoom setting and lens aperture to use and how large the dog should be in the photograph. Many people spoil an attractive landscape by placing someone in the foreground; not sufficiently large to be a portrait but large enough to spoil the picture. Beware of the split-interest photograph which unfortunately is fairly typical of many holiday snapshots.

Most photographers will take only horizontal pictures because the camera is designed for ease of handling when held horizontally, but occasionally a vertical image is more appropriate.

Generally speaking, the horizontal or landscape format is appropriate for many landscapes or any picture intended to convey peace and tranquillity, whereas a vertical or portrait format suggests imposing subjects, like high buildings or tall natural objects such as a section of coniferous woodland or an avenue of Lombardy poplars. Close-ups of people often look more effective in the portrait format, whereas children running across the field of view will fit the horizontal format much better. These suggestions may be discarded when the subject calls for a more radical approach.

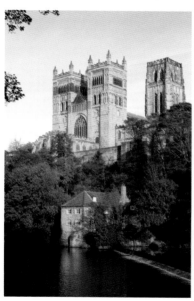

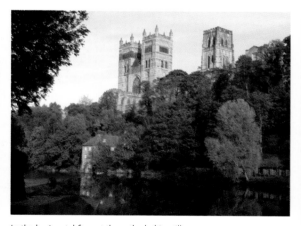

In the vertical format Durham Cathedral stands tall, dominating the picture.
APERTURE PRIORITY, F/5 AT 1/200 SEC, ISO 80 −1/3 STOP, TRIPOD.

In the horizontal format the cathedral is still dominant but less so, becoming part of a much larger picture with more emphasis on the trees in their autumn colours.
APERTURE PRIORITY, F/5 AT 1/100 SEC, ISO 80, TRIPOD.

What is the 'perfect' shape for a picture and why are so few paintings in art galleries completely square? It may be linked with something known as the golden section or golden rectangle. Artists have long proportioned their works to approximate the form of the golden rectangle, which has been considered aesthetically pleasing. The ratio of the short to the long side is 1:1.63. So, for example, a 10 x 16cm picture has a ratio of 1:1.6 while on A4 paper (21 x 29.5cm) the ratio is 1:1.7. I don't know if our attraction to this rectangular shape is cultural or inherent in our nature, but a ratio of around 1:1.7 always seems to produce a satisfactory shape.

The edges of the picture are important because in a composition without a frame, the eye tends to wander out of the picture. It is good practice, where possible, to frame the picture using overhanging trees, the bough of a tree, an archway or even a dark area of sky. The frame base could simply be some dark rocks in the foreground.

Subject, position and size The obvious place for the subject is right in the centre of the frame where it will have immediate impact. Unfortunately, the interest is usually short-lived and eventually the image becomes quite boring. This can be avoided by moving the subject towards the side of the frame in a position suggested by the 'rule of thirds'.

Divide the image area into thirds using imaginary horizontal and vertical lines. Where the four lines intersect are the 'strong' points – near which the subject should be located. The rule of thirds is something inherent in the human psyche, being closely related to the golden rectangle. It was probably known and used by the Egyptians some 5,000 years ago; it was certainly employed by the Greeks in their art and architecture and is still universally used today. Having located the main subject near one of the strong points, it is good practice to have it looking into the area of greatest space, because it provides space for the subject to move into.

The relative size of the subject is also important, with 'large' not always having the greatest impact. At the other extreme, too small a subject loses its significance, becoming just a minor component of the total image.

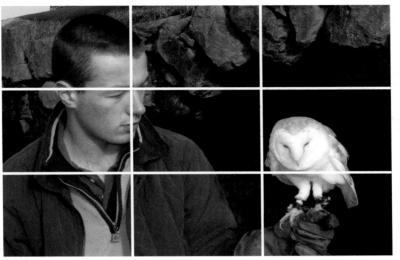

Eye lines are real or imaginary lines which lead the eye around the picture (usually starting on the left side because in Western culture we read from left to right), consciously or subconsciously helping the brain to seek out and identify patterns, shapes and objects of interest. An obvious example is the curved line of a river which can lead the eye quite naturally through the picture taking in various points of interest before it ends at a specific point of interest, such as a castle, or disappears over the horizon.

Eye lines and image balance

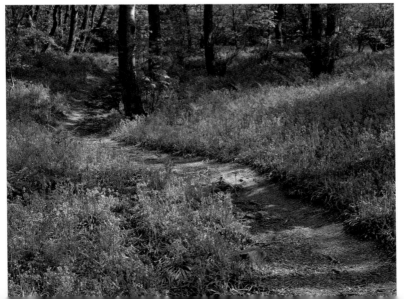

Bluebell wood, with path starting at the bottom left and winding its way up and across the frame, making it quite natural for the eye to follow. PROGRAMME, F/11 AT 1/60, ISO 80, TRIPOD.

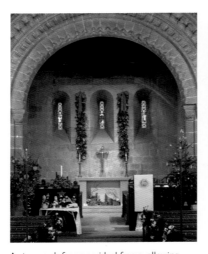

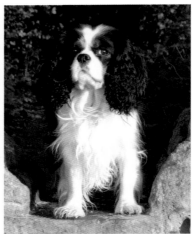

A stone arch forms an ideal frame, allowing the eye to concentrate on the crib scene, altar and cross.
PROGRAMME, F/4.0 AT 0.5 SEC, ISO 100, TRIPOD.

Cavalier King Charles spaniel waiting on a stone stile, which forms a firm base for the picture.
PROGRAMME, F/5.6 AT 1/150 SEC, ISO 100 −1/3 STOP.

A composition in which the main subject resembles a triangle suggests solidarity and stability, while a diagonal line or a triangle balance on one corner implies instability, motion and dynamism. An L-shaped configuration also suggests stability and is often used to frame a landscape, while an inverted U-shape is frequently utilized in the form of a stone arch or overhanging foliage to frame a scene and give it stability.

The composition of a picture is often linked to the camera position, in that a low camera position will not only enhance the immediate foreground and reduce the middle distance, but will also allow small nearby objects to stand out more dramatically. This is the ideal camera position when photographing toddlers playing in the garden. A higher camera position results in a field of view similar to that of a man standing upright and, although this is often used (more by default than for any specific reason!), it is not necessarily the most appropriate position. Pointing the camera vertically down can result in another interesting viewpoint when

photographing, for example, crocuses in the garden. Lying on your back and pointing the camera up at the sky can also result in an unusual image.

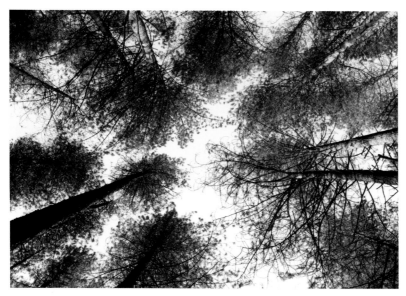

Lying on your back and pointing the camera directly upwards produces an interesting image: a good example of radial symmetry.
APERTURE PRIORITY, F/3.5 AT 1/160 SEC, ISO 100 +1/3 STOP, HANDHELD CAMERA.

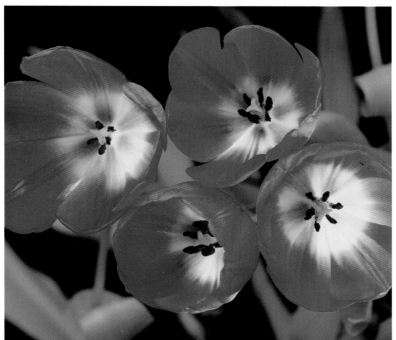

A different perspective – tulips viewed from above.
APERTURE PRIORITY, F/11 AT 1/60 SEC, ISO 100, TRIPOD.

Colour The palette of pure colours consists of the primary hues: yellow, red and blue, so-called because all other colours can be made from them. When mixed in pairs they produce the secondary colours: orange (from yellow and red); green (from yellow and blue) and violet (from red and blue). When these secondaries are mixed with their adjacent primaries, six tertiary colours are formed, such as yellow–orange, red–orange and so on. Colours from opposite sides of the colour wheel, such as red and green, form harmonious relationships and look well together.

Images which are predominantly one colour evoke a particular emotional response. For example, yellows and reds are associated with sunsets, inducing feelings of warmth and even intense heat. Blue, the colour of the sky and water, is a 'clean' but 'cool' colour implying peace and tranquillity. Blue-grey is a cold colour, which is strikingly effective in winter scenes where it creates an atmosphere of desolation. Green is a restful colour associated with grass and trees, promoting feelings of space and calm, hence the 'green room' in theatres and TV studios. It is also a 'receding' colour, making it useful as a non-distracting background in close-up work, while certain shades of red are 'advancing' colours, which seem to push themselves forward.

A basic colour wheel showing the primary colours of red, blue and yellow, with their secondary colours, violet, green and orange.

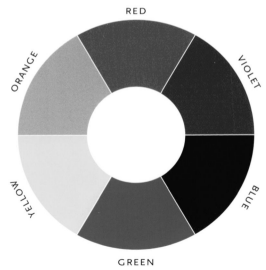

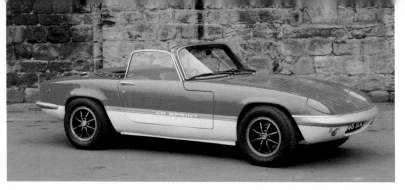

Red is an 'advancing' colour and always looks good on a sports car, such as this Lotus Elan Sprite. PROGRAMME, F/11 AT 1/125 SEC, ISO 100, TRIPOD.

Colour saturation (in photography) refers to the intensity or 'richness' of the colours. Unsaturated colours are pastel shades; fully saturated colours are strong and vibrant. If you want an image to feel balanced, a large area of light colour should be counterbalanced by something smaller and more dense, or larger and lighter on the other side of the frame.

Colour and black and white represent two entirely different and distinct means of capturing an image. One is not better or worse than the other – just different, performing different tasks.

Black and white

There are at least two areas where black and white can be used successfully. In portraiture you can capture the very essence of the sitter without the distraction of colour. Ruddy complexions or blotchy skin are often less obvious in black and white, while a little side-lighting can bring out the texture of the skin in a mature, weather-beaten seafarer (see page 90).

Views that include bold structures such as castles or churches can look very atmospheric as silhouettes against a dark leaden sky. The effect can be enhanced with colour filters (which I used extensively in my old black-and-white days). Yellow or orange filters will darken a blue sky, while a red one produces a really dramatic effect. Red filters will also cut through haze, while polarizers reduce surface reflections from non-metallic surfaces and also darken blue sky. Yellow/green is used to lighten grass and foliage. Sometimes they can be used to correct or separate colour tones. Red and blue are often indistinguishable, appearing as dark grey, but the prime use of these filters is to produce exaggerated effects such as the dramatic skies mentioned above.

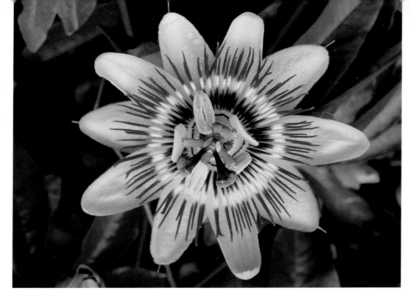

A passion flower viewed from above, illustrating perfect radial symmetry. APERTURE PRIORITY, F/11 AT 1/25 SEC, ISO 100, TRIPOD.

Patterns and symmetry

Pattern, like rhythm, is based on repetition, allowing the eye to roam freely across he image, engendering a feeling of predictability and even restfulness.

Some patterns are based on radial symmetry, with the elements spreading out from a central point as seen in many flowers, such as daisies, dandelions and ragwort, and in multi-coloured parasols and umbrellas. The centre of the pattern would normally be placed at one of the strong points in the frame, but occasionally the rule of thirds can be broken by locating the pattern centre in the middle of the frame, emphasizing the perfect radial symmetry of the subject.

Lighting

Lighting can make or break a photograph. Amateur photographers often pay scant attention as to how the subject, be it a person, group, building or landscape, is being illuminated.

Lighting at the extremes can be either hard and unyielding or soft and subtle, each creating its own effect on the subject. Harsh light is emitted from a point source, resulting in high contrast lighting with dark sharp-edged shadows, as typified by the midday sun in a clear blue sky. This type of lighting is shunned by most photographers because the contrast is too high and the shadows too blocked up.

As the light source increases in diameter, the shadows become more soft-edged, as when a flash is fired into a flash umbrella. The size of the light source is equal to the area of the 'brolly' flash, resulting in softer lighting with more detail in the shadows. On a completely overcast day, the sky is an unbroken hemisphere of flat, diffused light with no shadows at all, which is not ideal for most photographic work (except, possibly, close-up photography).

DIRECTION OF LIGHTING

Frontal lighting is 'safe' lighting because everything facing the camera will be clearly lit, hence the advice given to amateur photographers to keep the sun behind them. Unfortunately frontal lighting is very flat and rather uninteresting, producing no modelling or three-dimensional effects. However, when the main light is in the 45° frontal position, i.e. 45° above and 45° to one side, it creates good modelling, which may or may not require a small fill-in light or reflector to lighten the darker shadows.

Other useful types of lighting include grazing (or low oblique) which emphasizes surface texture and is used extensively in both landscape and close-up photography (see box, right). Backlighting is favoured by many photographers (including myself), where the main light is behind and usually above the subject and directed towards the camera. It works well for photographing animals and plants fringed with delicate hairs or fine bristles, and with people who have a full head of fair hair. As the light is shining almost directly into the camera lens you will need to use an efficient light shield such as a conventional lens hood or a piece of card (or your hand) held just out of the picture area, shading the lens from direct sunlight.

Although compact digital cameras are not equipped to take either filters or lens hoods, most have a deeply sunken lens with a light-shielding, rectangular cut-out plate located in front of the lens, serving as a rudimentary lens hood.

- **Grazing**
This occurs when the light is shining almost horizontally, such as at sunset. The light grazes the surface of the ground, highlighting surface detail and texture. It also applies to the use of artificial light for still-life work.

Flat frontal lighting, typical of many camera flash shots, is ordinary but safe. APERTURE PRIORITY, F/8 AT 1/15 SEC, ISO 80, TRIPOD.

Backlighting lightens the dog's back and head and separates it from the background. APERTURE PRIORITY, F/8 AT 1/6 SEC, ISO 80, TRIPOD.

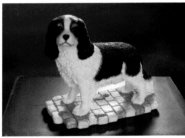

Grazed lighting from the right side highlights the detail in the dog's coat. APERTURE PRIORITY, F/8 AT 1/8 SEC, ISO 80, TRIPOD.

Depth and perspective You can check how a scene will look in a photograph by closing one eye for a while. This will eliminate the three-dimensional stereo effect of using two eyes, reducing the scene to a flat two dimensions, exactly as it would appear in a photograph. After a minute or so viewing the scene with one eye closed, open both eyes and note the amazing effect of seeing the three-dimensional image again – quite a revelation!

You can produce an illusion of depth in a two-dimensional photograph by, for example, photographing two objects of similar size but at different distances from the camera, when the nearer one will be larger than the more distant one. Although this may seem obvious to us, in early paintings the larger the person, the more powerful he was deemed to be, regardless of where he was placed in the picture.

Another way of generating depth in a picture is to include some form of linear perspective, where parallel lines, such as the banks of a canal or railway line, converge towards the horizon.

Colour changes can also help to impart a feeling of depth and atmosphere to a photograph. Due to atmospheric haze produced by moisture and dust particles in the air, far-away objects slowly lose their strong colours, which are replaced by pastel-shade greys and blues. Definition also suffers as distant hills and mountains look much less distinct than those in the near and middle distance. In places with crystal clear, haze-free atmosphere, such as Iceland, the 'depth' effect is completely lost with everything from the near distance to the horizon being sharp, clear and full of colour but completely flat and two-dimensional. Remember that a wideangle zoom setting stretches the perspective, producing exaggerated depth, while the telephoto setting has the opposite effect.

Before taking any picture consider the composition carefully and then, when you are quite happy with it, release the shutter. In the end it's not the camera but the person behind it that really counts.

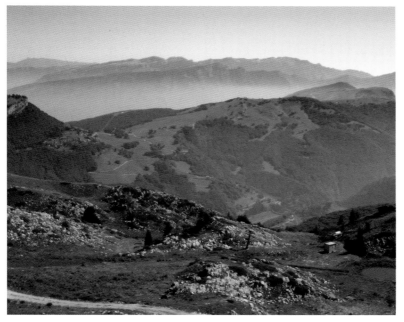

Colour changes can help to achieve a feeling of depth and atmosphere to a photograph. The foreground has strong colour, whereas the distant mountains slowly lose their colour, which is replaced by pastel-shade greys and blues. PROGRAMME, F/7.1 AT 1/600 SEC, ISO 100.

CHOOSING A CAMERA

..

5

WITH SO MANY compact cameras on the market, choosing the right one can be a daunting experience. Here are some basic requirements that should enable you to choose a new or upgraded camera, confident that it will fulfil all your needs.

Personal requirements Are you a general photographer, wanting to record family, friends and holidays, or do you also have a special interest? For example, a landscape photographer will often require a wideangle zoom lens to capture a panoramic view; a bird photographer would need a long zoom lens (10x or even 12x); and someone interested in nature and close-ups would need some control of the lens aperture and the ability to focus manually, thereby keeping the most important parts of the flower or fungus in sharp focus.

How portable do you want your camera to be? Many cameras are small and can be slipped into a pocket or handbag. The larger compacts would be carried in a conventional case or pouch with a shoulder strap. Holding the camera and operating the major controls is vital: people's hands and manipulating powers vary and this can only be determined by handling a few cameras in the shop.

Camera requirements Most digital compacts come equipped with an adjustable zoom lens enabling you to vary the size of the image. The normal zoom range is 3x or 4x, although 10x and 12x zooms are also available should your interests require it. The 3x zoom would normally range from around 35mm (35mm film equivalent) wideangle to 105mm at the long end, whereas a powerful 10x zoom would stretch to 350mm – ideal for action and wildlife photography.

Virtually all compact cameras have built-in autofocus, which normally works extremely well. Problems can arise when the subject is not in the centre of the frame, such as when two people are being photographed side by side. The camera will often focus on the background between them, unless it has a face-recognition facility.

Autoexposure (AE) settings are standard on all digital compacts. The most basic is the auto setting; the point-and-shoot mode, in which the camera controls everything. The programme (P) setting is more useful: in this mode the camera selects the aperture and shutter speed but allows full control of other settings such as ISO, exposure compensation and so on. If you want greater control, you will need a camera with aperture priority (A), shutter priority (S) and manual (M) settings. Look for the auto PASM markings on the mode dial (see page 24).

(see page 24)

A collection of scene (SCN) settings such as 'snow', 'fireworks', 'night scenes' and so on, are also worth having. The camera selects the appropriate settings to ensure a well-exposed picture. You may also want a shutter-release delay setting, which will allow you, the photographer, to be included in the photograph.

Autoexposure and scene settings

In bright sunshine the screen image is often difficult to see, or even blacks out completely. Although a screen shade can help, some photographers prefer the back-up provided by an eye-level viewfinder. This is only available from a few manufacturers, principally Canon on most of its digital compacts, and Casio, Fujifilm, Samsung and Kodak on one or two of their compacts.

Useful features

As a general rule of thumb, 3mp are required for a high quality 6 x 4in (15 x 10cm) enlargement; 3–4mp for a 7 x 5in (18 x 13cm) print; 5mp for A4 and 6+ megapixels for a large, top quality A3 enlargement. However, I have a 4 megapixel camera and have produced some extremely good A4 pictures from it; even A3 enlargements are not beyond the reach of this little camera.

Sensor resolution

Camera reviews can be found in all digital camera magazines, in *Which?* consumer magazine and online. Cameras can be bought on the internet or by mail order but it may be better to use a high street camera retailer, where you can provide a list of requirements, examine and hold the camera. You may have to pay slightly more for your camera, but you will have examined it properly.

Buying a camera

Camera care Your digital compact camera is a delicate electronic instrument, not built to withstand abuse, but, if well looked after, will provide years of reliable service. Always keep it in its case when not in use. Soft leather cases look stylish but do not offer as much protection as bulky, padded cases, which will even protect the camera if dropped. Keep the camera clean at all times, using a soft microfibre cloth on the body and LCD screen and a blower brush or compressed air for cleaning the lens surface and lens barrel.

SAND AND WATER

If you use your camera in wet conditions, protect it with a fitted plastic cover or plastic bag. If you should accidentally splash any water onto the camera, wipe it immediately with a clean, dry cloth. Exposing your camera to saltwater is more serious and can lead to corrosion and malfunction of certain components. To limit any damage, ensure you wipe the camera with a damp cloth as soon as possible. Should you accidentally drop your camera in water, quickly retrieve it, dry it off and allow it an hour or so to dry out; however, the chances of having a fully functional camera may be rather slim.

Do not be tempted to take photographs on a windy beach, as sand is abrasive and can easily damage the lens surface or become lodged in the retractable lens barrel. If you have been using your camera in a dusty environment, clean the lens and exterior with compressed air as soon as you get home.

Tempting as it is to photograph children splashing about in the sea, it can spell death to the camera if it is accidentally splashed or dropped into the water.
PROGRAMME, F/3.5, AT 1/500 SEC, ISO 200, HANDHELD CAMERA

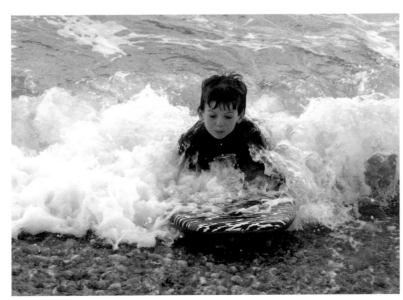

High temperatures and humidity will cause condensation on a cool camera. Warm up the camera beforehand and keep it wrapped up until ready to use.
APERTURE PRIORITY, F/5.6 AT 1/120 SEC, ISO 100, HANDHELD CAMERA

HEAT AND HUMIDITY

If moving from a dry temperate environment into a hot, humid atmosphere, the camera lens, body and innards will very quickly become covered in condensation, making the camera unusable. In these conditions the camera, when not in use, should be kept in a sealed plastic bag containing plenty of silica gel bags to absorb the moisture. The damp silica bags can be dried out afterwards to restore their moisture-absorbing properties. Allow the bag to reach the ambient temperature before removing the camera.

FREEZING TEMPERATURES

Sub-zero temperatures will adversely affect the performance of the battery and therefore the camera. Protect the camera under warm clothing until you are ready to use it. Keep a spare, fully-charged battery warm by burying it as close as possible to your torso.

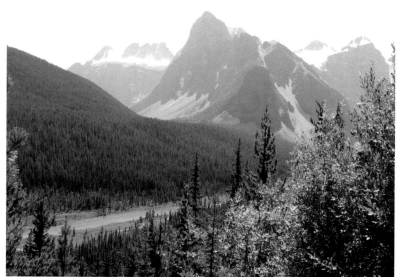

Sub-zero temperatures experienced at high altitudes will affect the performance of the battery and camera.
APERTURE PRIORITY, F/5.6 AT 1/250 SEC, ISO 80, HANDHELD CAMERA

AFTER THE SHOT

<div style="text-align:center">6</div>

YOUR RECENTLY TAKEN photographs can be viewed on the TV screen or printed at home using a stand-alone printer/copier. But most photographers are keen to download their images into the computer, allowing them to be manipulated or corrected as required. They can be altered in various ways, including cropping, colour adjustment, sharpening, red-eye removal and so on. Your options are almost limitless, requiring only basic computer skills.

Non-computer methods

VIEWING PHOTOGRAPHS ON TELEVISION

One of the best and quickest ways to view your photographs is on a television screen using the AV cable supplied with the camera. The small jack plug connects to the camera's 'AV OUT' socket, with the other ends plugged into the 'VIDEO IN' and 'AUDIO IN' sockets on the TV. Turn on the TV and switch to the video channel (AV1 – AV3) to receive the signal from your camera. With the camera switched on and set to the playback mode, the pictures should appear on the TV screen. If not, try other AV channels until the picture appears. Scroll through your images using the camera's four-way switch, enlarging them with the zoom lever. Some of the latest LCD televisions can take memory cards, with the TV remote control handset used to access the pictures.

PRINTING AT HOME

It is possible to print photographs direct from your camera, as long as both the camera and the printer are PictBridge compatible. Look for the PictBridge logo on your equipment or in the instruction booklet. However, this is a fairly slow method of printing and camera battery drain is inevitable. The best method is to print your photographs from the memory card. Most modern printers are equipped with a range of slots to accept all the current memory cards; some feature a small fold-down LCD screen to show the images, allowing you to view and modify them prior to printing.

Most printers are quite versatile and, using a 'Print Options' menu, you can select image and paper size, paper type and layout style. A 'Photo Edit' menu will allow you to enlarge the image, lighten or darken it, rotate it and remove red-eye. These days, the quality of home-processed prints is high and they are fairly quick to produce, but photo-quality paper and the inks are expensive.

Smaller, lighter portable printers are also available, producing 6 x 4in (15 x 10cm) prints using mains or battery power. They could even be used on holiday to print the day's photographs.

The copier/scanner/printer is a very versatile three-in-one unit able to scan photographs into a computer, photocopy, and print photographs from a memory card. It also has a PictBridge socket, allowing prints to be made from any PictBridge compatible camera.

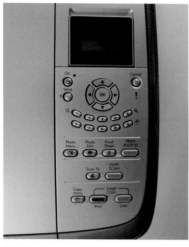

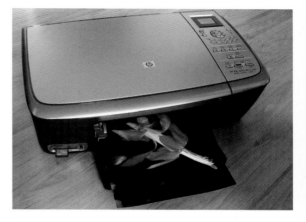

The three-in-one machines include a useful screen which indicates the choices available using the built-in menus. These include the number of copies, paper size, type and quality, density levels and so on. They are easy to operate from a well laid-out top panel.

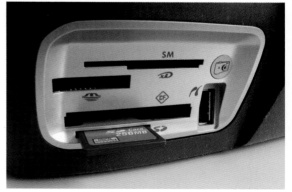

Most printers will accept all the current memory cards. This one is a secure digital (SD) card next to a PictBridge socket.

PROFESSIONAL PROCESSING

Professional digital processors are now widely available in high street camera shops and at specialist processing outlets. The quality is excellent and, if you order a large number of prints, the cost per print is very low indeed. Using a self-service machine you simply slot in your memory card or CD and decide which images you want printing and at what size. A standard 6 x 4in (15 x 10cm) print does not have the same aspect ratio as the image sensor or the LCD screen, resulting in the top and bottom edges of the print being cut off. The 'correct' size for a print from a 4:3 aspect sensor is 6 x 4½in (15 x 11cm) and no doubt these will soon become available. Your selected images are either processed immediately, within the hour, or the following day.

You can also have professionally processed images by mail order. Send a completed order form, plus the memory card or CD to the processing company, and they will send back your prints and memory card within a few days. Online photo processing is becoming more available. After uploading your images onto the appropriate website you select the ones you want printed and, after some basic editing such as cropping and removing red-eye, you pay online and the prints arrive in a few days.

Using a computer If you have a computer and are reasonably familiar with its basic functions, transferring the images from the camera or memory card to the computer opens up a whole new world of image manipulation. I use Canon cameras and their associated software in my computer, so the following information may not apply in detail to your camera/computer set-up, but the general principles should be the same. The applications apply to PCS only.

DOWNLOADING IMAGES FROM THE CAMERA (DIRECT TRANSFER)

It is first necessary to install in the computer the software supplied with the camera. Put in the disc, click 'Easy Installation' and, when the transfer is complete, click either [FINISH] or [RESTART]. Link the camera to the computer using the USB cable supplied and, when the 'Direct Transfer' menu is displayed on the camera's LCD

monitor, press the print/share button when the blue light will show. Select from the menu 'All Images' or 'New Images' (this only transfers and saves the images not already transferred). The blue button will blink while the downloading is in progress. The display will return to the 'Direct Transfer' menu when the downloading is complete. To cancel the downloading press the 'FUNC/SET' button. By default the downloaded images are saved into the computer's [My Pictures] folder.

All the pictures from the camera will be displayed as small, medium or large 'thumbnails' and double-clicking on any thumbnail image will open it fully.

DOWNLOADING FROM THE MEMORY CARD

Some of the latest computers will accept any of the current memory cards, or you can use a separate card reader which is plugged into one of the USB sockets on the side of the computer.

When the card is slotted in, the screen shows 'found new hardware'. The computer will automatically read the details from the card and the icon will be displayed on the screen (this will disappear when the card is removed).

To store the images permanently on the computer, go to 'Windows Explorer' to bring up the images. Double-click 'My Computer' and put the curser on your card reference (for example, SD card is removable disc G, Disc is removable disc D and flash drive – memory stick – is removable disc E). Double-click to bring up the folder showing all the images in that folder. Double-click and go to 'file', then 'new folder' and type in a title for the folder. Go to 'Copy all images' and double-click – all the images will be stored under the folder title you have just typed in. If you just want to save a few of the images, hold down the Ctrl key and click on each thumbnail you wish to store. Finally, to select a few consecutive images, click and hold down the Shift key, clicking on the first and last thumbnails in the list of images you wish to select.

Many computers can accept memory cards to transfer the image to the computer; otherwise, use a separate memory card reader that can be connected via a USB lead.

A popular and convenient method of storing files and folders is with a USB flash drive, which plugs into a USB socket on the computer. Storage capacity ranges from 128MB to several gigabytes.

TRANSFERRING IMAGES TO THE MEMORY STICK OR CD

Although images from the computer can be burnt onto a CD, many people prefer the convenience and portability of a compact memory stick (or USB flash drive). Transfer of information to the memory stick is very fast and information can be later added or removed. Turn on the computer and click on 'My Documents', then click on your chosen folder for copying. In the folder click on 'File to be saved'. Click on 'Edit'. When a menu comes up, select and click on 'Copy'. Go to 'My Computer' and double-click on 'Removable Disc E' (the memory stick). Select and click 'Edit' and on the next menu select and click on 'Paste'. The memory stick will flash as the images are being transferred. Using the same method, images can be transferred and burnt onto a compact disc (CD-R) by clicking on 'Removable Disc E'. A CD-R can only be used once, whereas a CD-RW can be used many times but it cannot be read until it is finished and all the files must be removed at once before it can be reused.

Basic editing

There is a wide choice of image modifications available such as trim, red-eye correction, colour brightness adjustment, sharpness, auto adjustment and insert text. This section deals with the more obvious changes you may wish to make: trim; sharpness; colour adjusment; and red-eye.

TRIM

Click on the file you require, then double-click on your selected image. Click 'Edit', followed by 'Edit Image' which produces a list of possibilities. Select 'Trim'. Click cursor on small image on bottom left of screen. Click on 'Finish' and a large image will come up on the screen with a tiny + at the top left corner. Hold down the left mouse and drag the cursor from the top left corner, across and down the image, pulling the cropping rectangle (known as the marquee) with it. Release the mouse button, move the cursor onto the square in the centre of any line and it will change to a double-headed arrow. Click and hold down the mouse and drag the line up, down or sideways. This can be repeated using the other three lines. Click right mouse to stabilize. After selecting the trim rectangle,

click 'Trim' and then 'Save As'. To name the new file, type in the untrimmed file number, add 'a' or 'b' to the end and paste the file into the 'Trimmed Images' folder – or to any other folder.

You can rotate the cropping rectangle by moving the cursor slightly up and down away from the centre square when it will change to a curved double-headed arrow. Click and pull the square up or down to rotate the rectangle. This technique can be used for correcting a sloping horizon.

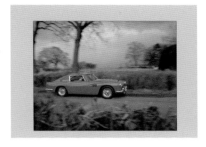 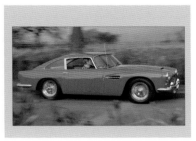

Many photographs benefit from some cropping. The procedure is quite straightforward.

The trimmed image has not only cut out a large area of background, but also highlighted the car, creating a stronger composition.

COLOUR ADJUSTMENT

Click on 'Colour Adjustment' to bring up a box showing brightness, saturation and contrast. The default setting puts the three rectangular marker boxes in the centre of the three horizontal lines and, using the mouse, you can click on each characteristic and increase or decrease the brightness, saturation and contrast as required. When satisfied with the results click 'Save As'.

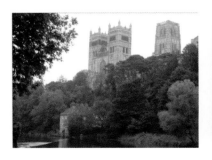 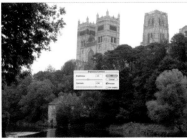

By the time I arrived at Durham Cathedral the weather was dull and slightly misty, resulting in a flat, lifeless image.

After trying various settings I selected 'Brightness –14', 'Saturation +50' and 'Contrast +50'.

SHARPNESS

Click on 'Sharpness' to bring the 'Unsharp Mask' box up on the screen. Click on 'Unsharp Mask' and then on 'Amount'. The degree of sharpness increases from 0–500 per cent, but at the maximum end the image becomes noisy and blotchy with 'jaggies' around the curved edge. For this image I used 100 per cent, a radius of two and a threshold of one (see box, below) which seemed to produce the most acceptable results.

- **Radius and Threshold**

The Amount setting controls the contrast of the pixels by increasing the edge differences. For successful sharpening use the Radius and Threshold settings in conjunction with Amount. The Radius setting allows you to widen the edge rims around the pixels. This helps sharpening without producing a 'halo' effect. A higher value affects a wider band of pixels. A Threshold of 0 will let you sharpen all pixels, including plain areas, which will result in unwanted noise. Use a higher Threshold setting to apply sharpening to areas of detail only. All settings are resolution-dependent, so a high resolution image will require higher settings. The settings used depend on the resolution of an image, the subject matter of the image, and on the type of printing to be used.

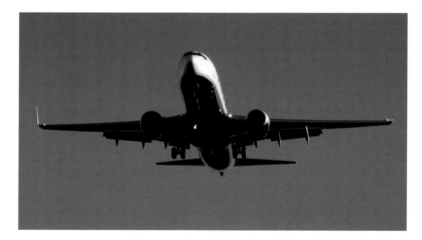

The original photograph of a passenger aircraft coming in to land.

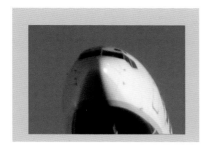 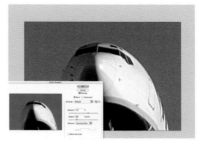

To make the sharpening process more obvious the image has been greatly enlarged – note the lack of detail in the cockpit area and the smooth blue sky.

The image was given the maximum sharpening of 100 per cent. The obvious effects are the increased detail around the windows in the cockpit area, the great increase in 'noise' demonstrated as general 'blotchiness', particularly in the sky, and the emergence of 'jaggies' on the curved edges of the aircraft.

RED-EYE

Unless precautions are taken (such as pre-flashing), photographs taken using the camera's built-in flash invariably suffer from red-eye, where light from the flash bounces back off the retinal blood vessels. The situation is exacerbated when photographing in poor light, as the pupils of the eyes are very large, making red-eye much more likely. Fortunately it is not difficult to eliminate. Bring up the required folder and the file of thumbnails containing the red-eyed image. Click on the image. Click on 'Select Editing Tool', to bring up a list of options. Click on 'Red-Eye Correction'; click on 'Finish', when you will be given the choice of using the 'Auto Mode' or 'Manual Mode'. Click on the red-eye icon at the bottom of the screen, then on the red-eye in the photograph. Click on 'Auto-Mode' and 'Start'; an egg-timer icon will show the progress of the red-eye colour removal. When using the manual mode, moving the cursor around the red-eye area reduces the red to dark grey. Finally, click on 'Save As' and the job is complete.

OUT AND ABOUT

LANDSCAPES

7

YOUR COMPACT DIGITAL camera slips easily into your pocket and you would like to go out and take some good landscape photographs. Stopping the car at an attractive view, taking a quick picture and moving on to the next scene which captures your attention is not the best approach. You will probably end up with a decent set of sharp, well-exposed photographs which are lacking in sparkle, drama and emotion; in other words a set of average snapshots rather than inspirational pictures.

Before starting there are one or two very useful accessories which, with one exception, can be easily slipped into the other pocket. These include a selection of filters, a small table-clamp tripod and some spare charged batteries. Finally, a small monopod or tripod would be a very valuable addition.

Choosing your subject Quite often during an outing in the car you might come across a potentially interesting landscape, packhorse bridge, waterfall or old barn, but rather than stop or hold up the rest of the party, make a note to come back later and spend time assessing the scene's potential. Returning with the camera, accessories and a small compass, park the car and use your feet to find the best vantage points. You must then decide exactly what you want to include in the photograph and begin thinking about the composition of the picture. If the direction of the light is not right for your purpose, the compass will indicate the best time of day for a return visit (see below).

- **Using a compass**
 Hold the compass level so that the needle is free to rotate and point to north. Rotate the compass body until north is lined up with the dark N end of the needle. The compass will now indicate N, S, E and W. Knowing that the sun rises in the east and sets in the west, you can determine how the landscape will be lit at any time of the day.

You may think that a wideangle view across a stretch of attractive moorland does not require much thought about composition, but do address the simple things, such as where to place the horizon. Don't place it right across the middle of the picture (remember the rule of thirds); and where do you place the rustic old barn or that little bridge? The wideangle setting on the zoom lens is ideal for highlighting the foreground. By moving in close to nearby objects, they can be made to dominate the picture and create a sense of depth and even drama. Change the zoom setting and the camera position until the framing and the composition are to your satisfaction. Using the zoom at its maximum telephoto setting can often result in very worthwhile images which are hardly visible using the basic wideangle setting. The downside is that distances are compressed and perspective is reduced.

It is worth remembering that we read from left to right in western culture and we automatically do the same when 'reading' pictures and photographs. So a bridle path, for instance, starting near the left side of the frame and working its way across and up the frame, taking in points of interest on the way, is a very satisfactory way of arranging things.

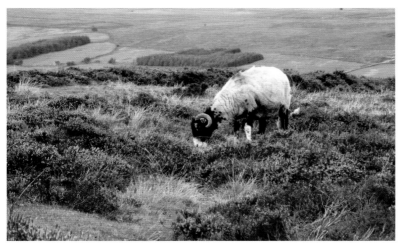

Moorland scene with sheep at the intersection of thirds and facing across the picture. The main horizon is approximately 1/3 from the top of the frame.
APERTURE PRIORITY 1/50 SEC, F/6.3, ISO 80.

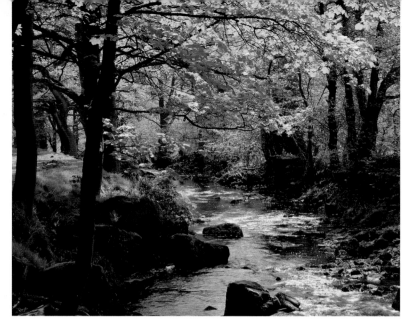

Backlit shot taken in late spring. Note how the eye naturally starts at the bottom left and follows the river up and round, resulting in an interesting image. APERTURE PRIORITY 1/125 SEC, F/16, ISO 200, TRIPOD-MOUNTED CAMERA.

Lighting The colour of light varies considerably throughout the day and over the year. The overall hue of daylight and artificial sources of light are measured in colour temperature using degrees Kelvin (K). The colour temperature of daylight varies from a red 1000–3000 K on a clear sunrise or sunset, to around 5400 K at midday. A clear blue sky can register a colour temperature as high as 15,000 K (almost violet). A cloudy sky with some blue in it would have a colour temperature of around 8000 K. As a result, the time of day and the type of sky will affect the overall colour balance of a scene.

KELVIN COLOUR TEMPERATURE SCALE

The colour of light is measured in degrees Kelvin. Digital compact cameras cope extremely well with mixed lighting.

Cloudy sky	Fluorescent light	Daylight	Halogen bulb	Household light bulb	Candle
8,000	6,000	5,000	3,000	2,500	1,500

Use a compass to determine how the landscape will be lit at any time of day (see page 62). Most landscape photographers prefer the quality of the light and its direction at sunrise and in the evening leading to sunset and beyond. At these times, the colours of the sky are at their most intense, while the lowish sun grazes the landscape, enhancing textures and undulations.

During the period before and after midday, the sun is at its highest and strongest with harsh lighting and blocked-up shadows – not the best time for landscape photography. Winter is quite a different proposition as the sun is always low in the sky, allowing a photographer to shoot interesting images throughout the day. Dramatic storm clouds are no impediment to great picture making. A stretch of bleak moorland or a craggy, rocky shore can look very dramatic set against a dark menacing sky, which can be further enhanced, if necessary, by using a neutral density graduated filter. You will capture atmosphere, tension and a sense of foreboding.

Fleeting shafts of sunlight look very dramatic and can highlight features in the landscape, adding to the drama. A rainstorm clears the air leaving everything new, crisp and fresh with well-saturated colours. Stay around and photograph it as it all unfolds.

A glorious winter sunset like this would have a colour temperature of around 1000 K and does not require any enhancement from the use of sunset filters.
APERTURE PRIORITY 1/60 SEC, F/4, ISO 80.

Filters Despite the digital camera lens being quite small and not threaded, a conventional filter can still be used by simply holding it in front of the camera lens. Most landscapes are sufficiently attractive not to require any obvious colour enhancement. Nevertheless, a graduated grey filter will reduce the contrast between the bright sky and the land without altering the colour in any way – a filter very popular with landscape photographers. This filter is usually available in two densities equivalent to one and two stops of the camera lens.

A polarizing filter is multi-functional, cutting down surface reflections on water, enhancing blue sky when the camera is at right-angles to the sun, reducing shine on foliage and increasing colour saturation.

No self-respecting landscape photographer would be without a couple of 81 series warm-up filters, which add a little warmth to any scene, particularly on overcast days. They are amber coloured and come in various strengths. The 81A and 81C are very useful; they can be used to enhance early-morning and late-evening light.

An ultraviolet (UV) filter is good for high altitude images. It can be used to filter out some of the blue light, resulting in a more natural-looking picture.

Late-afternoon sun produced grazed lighting with highlighted details in the rocks and heather.
PROGRAMME 1/30 SEC, F/8, ISO 80, TRIPOD-MOUNTED CAMERA.

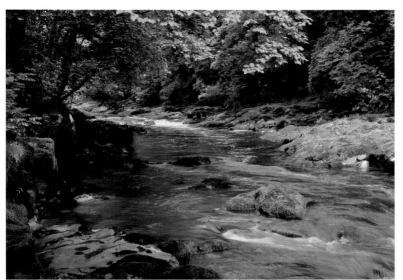

River scene photographed without using any filters, leaving the green leaves looking rather too bright.
APERTURE PRIORITY 1/125 SEC, F/8, ISO 100.

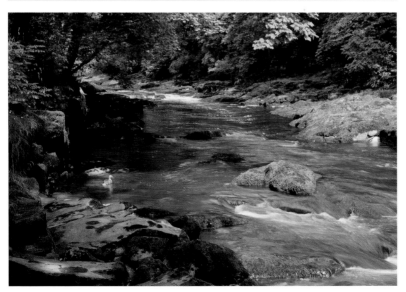

The same scene 'warmed up' slightly using an 81C amber filter requiring 2/3 stop more exposure.
APERTURE PRIORITY 1/60 SEC, F/8, ISO 100.

Aperture and shutter settings If your camera has aperture control, then for landscapes (and many other subjects) a small aperture and a greater depth of field is recommended. When we see a landscape, each component we look at is automatically kept in focus by our eyes. This should also apply to viewing different parts of a photograph. Occasionally this rule can be broken when, for example, an arch in the foreground helps to frame the picture, but might be allowed to go out of focus.

If your camera does not have aperture control, choosing a landscapes mode will automatically stop down the lens a little. Although a small lens aperture is ideal for landscape photography, it is at the expense of longer shutter speeds, which is why all keen landscape photographers use a tripod for maximum stability.

Exposure When photographing an average landscape, getting the 'correct' exposure is not normally a problem, because the camera's evaluative (multi-segment) metering system is extremely accurate. However, there are occasional exceptions, for example, when photographing a landscape with a large area of very bright sky in comparison to the land. The latter is likely to be underexposed and the obvious solution, used by all landscape photographers, is to use a graduated neutral density filter to reduce the contrast between the two areas.

Camera position and stability Most people instinctively hold the camera horizontally (known as the landscape position); after all, it is designed to be held in this way. Horizontal photographs are almost the norm, fitting in well with our normal field of view. However, there are occasions when holding the camera vertically (the portrait format) can result in a more successful picture – photographing coniferous woodland, waterfalls, tall buildings or full-length portraits, for example.

When photographing a landscape it is quite natural to stand upright and hold the camera at eye level. This includes most of the middle distance, but if this area is not too important, kneeling down and lowering the camera will increase the foreground area. This will reduce the middle distance and should produce a more acceptable image.

Holding the camera at almost arm's length to view the LCD screen is a natural position but not a very steady one. I recommend the use of a small table-clamp tripod and a monopod (see page 30).

With a little care, patience and a good eye for composition and lighting, superb atmospheric photographs are well within the compass of any digital compact camera owner. So, head off for the mountains, dales or the coast and make your camera earn its keep.

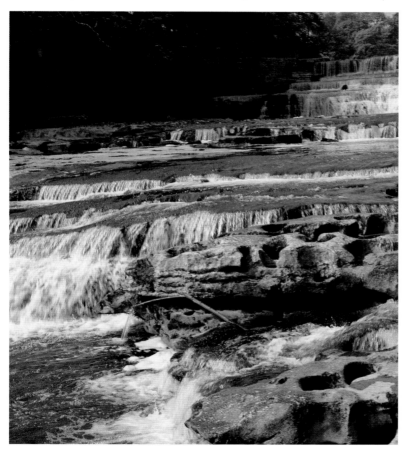

Aysgarth Falls in the early morning. The general direction of the water is diagonally across the page, suggesting dynamism and action. The overly dark trees at the top left are balanced by the rocks at the bottom right. APERTURE PRIORITY 1/125 SEC, F/11, ISO 100, TRIPOD-MOUNTED CAMERA.

NATURE

8

WHEN MOST PEOPLE think about nature photography, subjects such as flowers and garden birds spring readily to mind, but this represents only a small part of the nature photographer's field of interest. It should also include studying seaweeds, fungi, ferns and lichens, fishes, amphibians, reptiles, birds and mammals.

There are three problems associated with nature photography. The first is camera and subject movement, which are amplified when working in close-up, making it virtually impossible to function without using a tripod. Subject movement can be reduced by using a wind-break (if it is a plant), while a short exposure will help to freeze the movements of both plants and animals.

The second problem is the shallow depth of field, which in close-up work can be reduced to a few centimetres. Stopping down the lens is the obvious solution but due to diffraction problems most digital compacts will only stop down to f/8–f/11.

The third issue is that sufficient light is required to allow a short exposure, thus avoiding possible camera shake and subject movement, and yet providing a well-exposed image. Diffused daylight (with or without flash) is fine for most outdoor work. When indoors, utilize natural light from a window. Supplement this with artificial lighting from a small desk light – the camera will cope quite well with the mixed lighting. Using the camera's built-in flash will produce frontal lighting that can be supplemented by a remote slave flash unit. Photographing animals and birds from a distance will require the longest zoom setting available. On my camera, the 6x zoom fully extended decreases the effective aperture from f/2.8 to f.4/8, reducing the light intensity by more than half. Many digital cameras now have built-in image stability technology, which certainly helps, but is no substitute for a good tripod.

In this chapter I have treated nature photography on a seasonal basis, with suggestions on what to photograph at different times of the year.

TREE BUDS

Spring

The horse-chestnut has large sticky buds, fluffy first leaves and, ultimately, the superb clusters of white or deep pink flowers standing erect like candles. The sticky buds are best photographed indoors using frontal lighting, supplemented by a second light at the side and slightly behind the subject. Horse-chestnut buds burst to produce fluffy-edged first leaves which, when backlit, can also result in a fine picture. If possible, select the smallest lens aperture for increased depth of field; failing that, use the Programme mode, but in both cases opt for manual focusing and a low ISO setting.

FLOWERS

There is an abundance of flowers in spring, from snowdrops, crocuses, daffodils and tulips to wild primroses, campions and wild garlic. Use a tripod to allow you to study the composition. If possible, employ manual focus to keep the important areas in sharp focus. If the outside lighting is rather flat, the image can be improved by adding some side-lighting or backlighting from a handheld video light. When photographing crocuses or snowdrops outdoors, a little snow around will add extra charm to the scene.

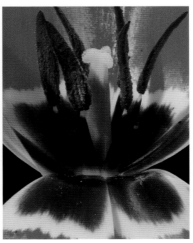

Horse-chestnut bud photographed indoors. Extra side-lighting highlighted the texture of the bud scales.
APERTURE PRIORITY, F/11 AT 1/15 SEC, ISO 100, TRIPOD.

Red tulip showing stamens and pistil against the red, yellow and brown-edged petals.
APERTURE PRIORITY, F/11 AT 1/30 SEC, ISO 100, TRIPOD.

AMPHIBIANS

Frogs mating. Taken near edge of pond with the zoom lens extended (6x) and the camera firmly mounted, keeping all four eyes in sharp focus.

APERTURE PRIORITY, F/8 AT 1/125 SEC, ISO 80, TRIPOD.

Spring sees the emergence from hibernation of frogs and toads and it is not too difficult to capture a good shot of a pair of frogs mating in a local pond. For my frogs photograph I set up the camera on a tripod with the zoom lens fully extended, arranging the camera's tilt and height until all four eyes were in sharp focus. Manual focusing was employed and for several shots I held a polarizing filter over the camera lens to reduce unwanted reflections in the water.

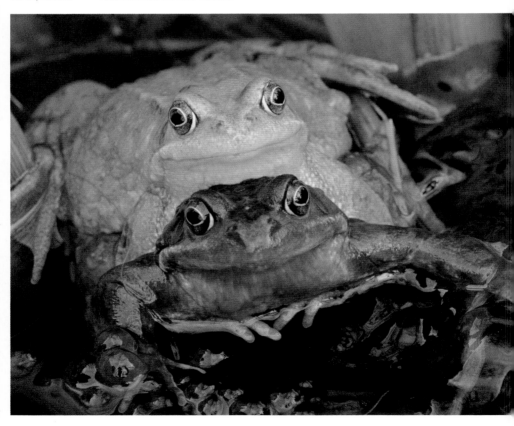

BIRDS

In spring, birds start building nests in preparation for egg-laying and rearing their young. The best approach for photographing birds is to work from inside the house or garage, but if that is not sufficiently close to the nest, erect a small hide and leave it empty for a few days until the birds become accustomed to it. It may be necessary to tie back a twig that obscures the nest but this should be done only rarely, taking care to release the twig as soon as you have finished photographing the bird. If your zoom lens is not sufficiently powerful to obtain a decent-sized image you might try setting up the camera closer to the nest, using a pneumatic release to trigger the shutter (this requires a shutter-release adapter accessory). Use the camera's flash, if possible supplemented by a more powerful slave flash set up nearer to the nest.

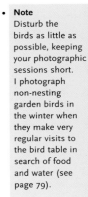

Note
Disturb the birds as little as possible, keeping your photographic sessions short. I photograph non-nesting garden birds in the winter when they make very regular visits to the bird table in search of food and water (see page 79).

Robin feeding young. Camera was set up about 10ft (3m) away from the nest, using a 32ft (10m) pneumatic release to operate the shutter-release mechanism.
APERTURE PRIORITY, F/11 AT 1/60 SEC, ISO 100, TRIPOD.

FLOWERS

Summer During the summer months with long days and maximum hours of sunshine, we can be spoilt for choice of things to photograph. Let us begin close at hand, in the garden. If you intend to produce an interesting and aesthetically pleasing image, it is worth concentrating on the lighting, composition, tone distribution and background. A rose garden is a joy to behold, though roses en masse do not translate well into a two-dimensional photograph. Instead, try photographing one or two flowers in close-up. The ideal illumination is diffused sunlight; you can decide whether this is to be a frontal, side- or backlight, remembering that frontal lighting is safe but not very exciting, whereas side-lighting will emphasize surface texture. Backlighting (rim or profile lighting) is worth experimenting with, and the results are often exciting.

As an alternative to working out of doors, why not take the flower indoors and photograph it in a controlled environment? In a conservatory or living room the composition, lighting, tone balance and even the background are all under your control. To provide an example of backlighting, I collected some sea campions and set them up outside in dark shade, with the strong morning

Rose photographed indoors on a dark background, using natural daylight and a handheld supplementary light.
APERTURE PRIORITY, F/11 AT 1/15 SEC, ISO 80, TRIPOD.

Red sea campion photographed outdoors in the shade, with a shaft of morning sun backlighting the flowers and stems. Manual focusing.
APERTURE PRIORITY, F/8 AT 1/30 SEC, ISO 180, TRIPOD.

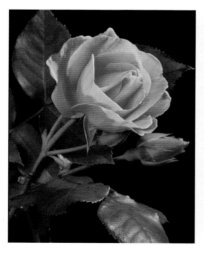
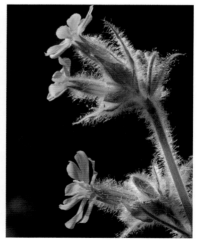

sun shining through them from behind. As the front of the flower and stem were rather underlit, a piece of strategically placed white card provided just enough frontal fill-in lighting.

BUTTERFLIES AND DAMSELFLIES

After locating your insect, move in very slowly, taking care not to cast any shadow on it. Make the first exposure before you reach the ideal distance, so that at least you get one shot, then make several more exposures as you approach. A small flash unit can be used if the subject is in dark shade or if the weather is dull and overcast; otherwise, natural sunlight is best. With flash illumination the background may register black, which looks unnatural. Reduce this effect by selecting a background that is close to the insect.

Swallow-tailed butterfly on fuchsia flowers. Photographed indoors against a blue background board with manual focusing. APERTURE PRIORITY, F/11 AT 1/15 SEC, ISO 80, TRIPOD.

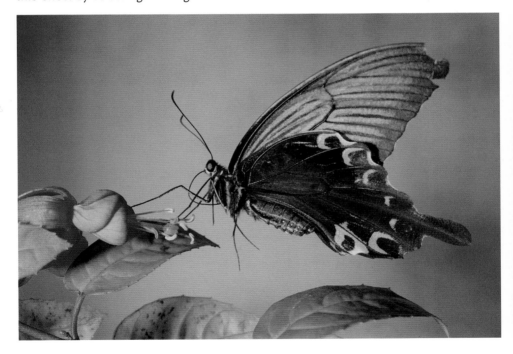

LEAVES

Autumn When photographing autumn leaves on the tree I would suggest using the sun as a backlight to highlight the warm colours. Try to choose a calm, windless day if you want sharp images. Handhold the camera using the programme mode and a low ISO setting.

A good still-life picture can also be created by arranging some leaves on a flat surface, such as a table. When I phographed the Norway maple leaf (below) I used a slide projector to beam light along the leaf, to increase the impact and highlight its texture. Then I added a few drops of water. The camera was positioned overhead with manual focusing, a small aperture and a shutter delay of around 2 sec to obviate any camera movement.

Norway maple leaf. The natural daylight was supplemented by a beam from a slide projector, which emphasized the water droplets. The eye picks up the top of the leaf stalk, following the lines of the leaf veins up and across the picture. APERTURE PRIORITY, F/11 AT 1/60 SEC, ISO 80, TRIPOD.

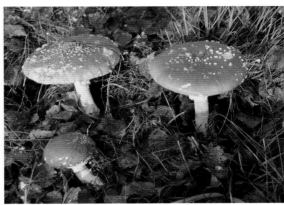

FRUITS AND SEEDS

Photograph sweet chestnuts and horse-chestnuts (conkers) on the woodland floor using the macro setting and built-in flash, or bring a selection indoors, arrange as a still-life and photograph with the camera overhead. Use flash or, even better, utilize the afternoon sun to produce some side-lighting (and better modelling). Select a small aperture for increased depth of field or, failing that, use the programme setting. If you are working within 20in (50cm) or so of the chestnuts, use a macro mode, if the camera has one. Select a low ISO setting (50–100) to obtain a smooth sharp image, using the shutter delay mechanism (self-timer) to avoid camera shake.

FUNGI

A large group of non-flowering plants that reach their peak in the autumn are the fungi. They are best photographed in the wild as some are quite delicate and most collapse quickly after being picked. Always choose a perfect specimen; a slug-damaged cap, for example, although quite natural-looking in the field, will appear rather unattractive on the final photograph. You will produce more interesting images if you work down at ground level, using the LCD screen to compose the picture. Natural lighting is fine but, as fungi tend to grow in shady areas, flash would be appropriate.

A carpet of sweet chestnuts arranged on a large tray on a kitchen table. Photographed from above, with the camera back parallel to the display to ensure a sharp image right across the frame.
APERTURE PRIORITY, F/11 AT 1/30 SEC, ISO 100, TRIPOD

The fly agaric (*Amonita muscaria*) is hallucinogenic and extremely poisonous. Photographed at ground level.
APERTURE PRIORITY, F/11 AT 1/15 SEC, ISO 100, TRIPOD

MAMMALS

Winter Some of the larger mammals, including red and grey squirrels, foxes, badgers and deer, provide excellent photo opportunities. Although these animals can be photographed handholding the camera, I prefer to use a tripod to ensure sharp, shake-free images.

Squirrels are particularly active, eating peanuts put out for the birds and burying some for a rainy day. Set up a tree stump containing some hidden nuts and wait for the action. Using the zoom lens fully extended should produce a reasonably large image. Mount the camera on a tripod, use the programme mode and select a medium ISO setting. If the weather is rather dull, the built-in flash plus a remote slave flash should produce a less flat image.

As red squirrels are smaller than greys, the 6x zoom lens was extended using a 2x teleconverter. APERTURE PRIORITY, F/5.6 AT 1/125 SEC, ISO 100, TRIPOD.

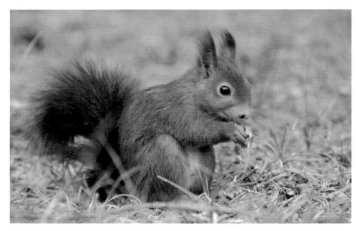

Badgers foraging for food in the early evening, highlighted by the setting sun. The zoom lens was fully extended (6x) and the camera mounted on a tripod. Badgers have a keen sense of smell so I stayed downwind of them. APERTURE PRIORITY, F/5.6 AT 1/125 SEC, ISO 100, TRIPOD.

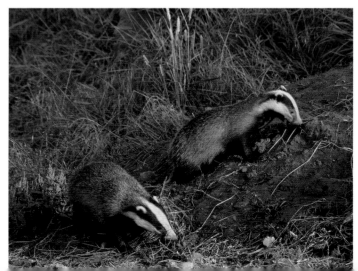

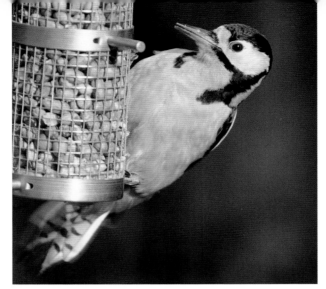

A rare visit by the great spotted woodpecker to a peanut holder. I managed to shoot two or three frames before it departed. Photographed through a specially made hole in the garden shed door using the full zoom extension (6x) and remote slave flash. APERTURE PRIORITY, F/11 AT 1/60 SEC, ISO 100, TRIPOD.

GARDEN BIRDS

Supply a bird table or a peanut holder with bird food and position a twig just above the feeding area, as birds will invariably perch on this before dropping down onto the food. This results in more natural-looking photographs. Or try hiding some food in a tree stump to provide another natural set-up. You may also need some form of hide. As most birds are quite small and very active, use a zoom lens setting of 6x or more to obtain a reasonably large image, coupled with a short exposure to reduce subject blur. Use a wide lens aperture (or the programme mode) and an ISO setting of at least 200 to help obtain a shorter exposure. Position a remote slave flash unit 45° in front of and above the bird table, using the camera's built-in flash to trigger it. Finally, use a tripod for extra stability and ease of focusing.

FLOWERS

Flowers are transformed when the petals and leaves become fringed with ice crystals. Use a white reflector to throw a little light on the front surfaces of the backlit petals. When it is cold and wet, try photographing flowers indoors. Select a small aperture (increased depth of field), manual focusing and a low ISO setting of 80–100 for a smooth, detailed image.

BUILDINGS

IT IS VERY EXCITING to see famous buildings for the first time, be they historical buildings such as Buckingham Palace, in the UK, or modern buildings such as the Guggenheim in Spain, or the Petronas Twin Towers in Kuala Lumpur. We invariably want to take photographs as soon as possible and of course this can be done in a matter of minutes. However, a professional architectural photographer may visit a building several times and then spend hours photographing it. Whilst I do not suggest that you do that, you can learn a lot from the professional approach, putting it to good use in your digital compact photography. When photographing the exterior (and occasionally the interior) of a building, there should be various aspects to take into account: the composition, lighting, converging verticals, time of the year and camera set-up.

Composition This is about finding the best viewpoint and arranging the various elements to make a harmonious whole. The first task is to decide whether to use a vertical (portrait) or horizontal (landscape) format. The former suggests strength and stability while the latter implies tranquillity, although in many cases the selected shooting position and the general shape of the building will determine which format to use. Your choice of viewpoint may be limited by other buildings, traffic signs, moving traffic or by masses of pedestrians. One approach is to use a wideangle zoom setting to get close to the building, while an obvious way is to wait for a lull in the traffic – both mechanic and human. To help the composition try, if possible, to avoid large unbroken areas of sky and introduce into the picture overhanging trees or even extensions from adjacent buildings – all this will help to produce a more satisfactory image.

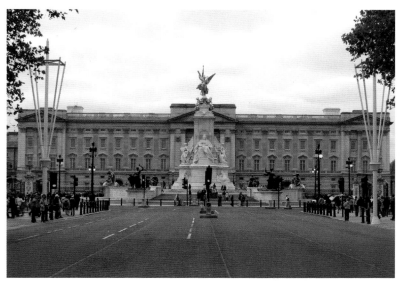

Buckingham Palace, London, UK. Built in 1703 for the Duke of Buckingham and now the home of the British sovereigns. Photographed from the middle of the road in Pall Mall. PROGRAMME, F/4.6 AT 1/250 SEC, ISO 100, HANDHELD CAMERA.

Lighting

The direction and quality of the sunlight is important in producing an attractive, well-lit photograph. You may be lucky on your initial visit and find the light is quite satisfactory; if not, it will mean using a compass to determine the best time of day. For example, if the compass indicates that the building is facing west, the best time to photograph it would be late afternoon, whereas the morning would be more appropriate for an east-facing façade.

Consider the quality of the light: a strong midday sun shining from a clear blue sky will provide too much contrast, resulting in burnt-out highlights and black, blocked-up shadows. A bright, slightly overcast sky producing fairly uniform lighting is often best, allowing detail to register in both the highlights and the shadows. Very occasionally, however, a strong sun producing high contrast lighting can be an advantage when photographing a modern building that features opposing angles and irregular symmetry. The result would be an interesting, abstract image in black and white.

The time of year is also important; in winter the sun may barely clear the horizon, leaving some buildings in permanent shade. If the building is set among trees or in woodland, autumn is a good time; you can include warm autumn tints in the composition. A snow scene can add interest, although lighting might be a problem.

Houses of Parliament and the Palace of Westminster, London, UK. Photographed from the south side of the river. PROGRAMME, F/4.5 AT 1/350 SEC, ISO 100, HANDHELD CAMERA .

Converging verticals When working in a confined space it may be necessary to tilt the camera to include the top of the building. This results in converging verticals, where the sides of the building lean in and the whole structure appears to be falling backwards. Although this can occasionally look quite dramatic, generally you would try to avoid it by finding a higher viewpoint from a nearby building or simply shooting from the top of a wall. Architectural photographers solve the problem by keeping the camera-back vertical and using an expensive 'shift' lens to correct the verticals. Although digital compact cameras do not have this facility, it is possible to resolve the problem using special computer software.

Camera set-up In order to obtain a sharp image and prevent the effects of camera shake, you will require a fairly short exposure of around 1/100 sec. If you are using a 6x zoom fully extended the shutter speed would be reduced to approximately 1/200 sec. This should not be a problem if your camera has an aperture/shutter priority mode. The programme mode, however, might not be ideal unless you use a higher ISO setting, which should result in a more useful aperture/shutter combination.

If you use a monopod or, even better, a full tripod, then a smaller aperture (sharper image and greater depth of field) and long exposure can easily be obtained. Select a low ISO setting for better quality, noise-free images; and try using the self-timer.

Modern architecture as exemplified by the Guggenheim museum in Bilbao, Spain. The complex angularity results in almost two-dimensional graphic design. PROGRAMME, F/5.6 AT 1/250 SEC, ISO 100, HANDHELD CAMERA.

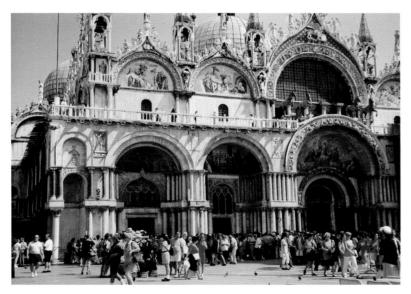

Basilica San Marco, Venice, Italy. A typical holiday shot. Basilica well lit by early afternoon sun. PROGRAMME, F/11 AT 1/350 SEC, ISO 100, HANDHELD CAMERA.

Interiors You will have noticed that when you walk from bright sunlight into a building such as a cathedral, initially the interior appears very dark indeed. This is exactly how the camera 'sees' the scene and unlike the human eye the camera cannot adjust to it, making the use of a tripod mandatory. Flash photography will be fairly ineffective – with no penetrating power beyond a few metres – and so the ambient light, which is usually a combination of daylight and artificial light, will have to suffice. As a building has depth, a stopped-down lens to increase the depth of field would be beneficial, but at the expense of a long exposure of perhaps several seconds – so you will need a firm camera support. Obtaining the correct exposure can be tricky because of the high level of contrast between the sunlit windows and the general interior – expose for one and the other will suffer. It would be prudent to check the post-shutter images and, if necessary, adjust the exposures until you reach a suitable compromise. Most digital compact cameras cope well with mixed lighting using the automatic default white balance setting.

Tiny Buddhist temple, Singapore. Flash-lit shot due to dull interior. PROGRAMME, F/5.6 AT 1/60 SEC, ISO 80, HANDHELD CAMERA.

Finally, as with outside shots, converging verticals are likely to occur and the remedies suggested earlier are also applicable here.

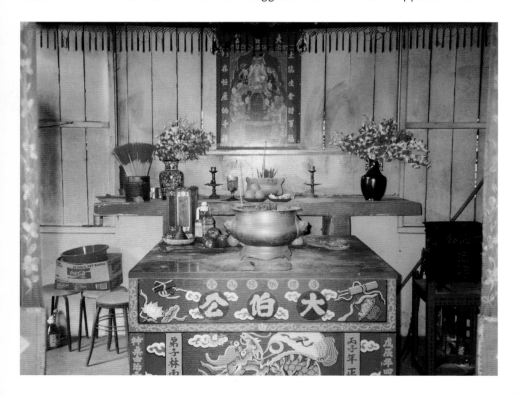

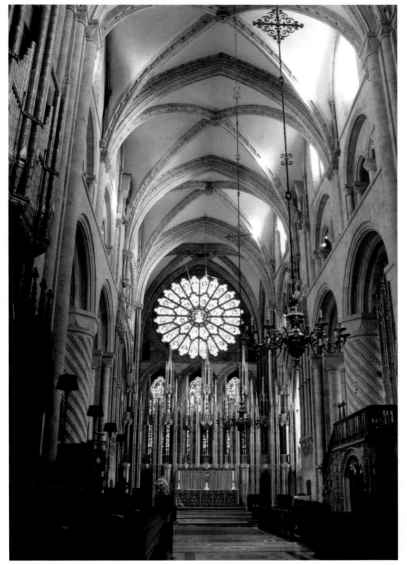

Durham Cathedral, UK. The interior, looking down towards the altar. The camera was handheld and supported on one of the pews. APERTURE PRIORITY, F/2.8 AT 1.6 SEC, ISO 200.

PORTRAITS

10

THERE ARE TWO categories of portraits: the formal and the informal or candid. In formal portraits you organize everything, including your sitter, whereas in candid portraiture you are more of a bystander reacting to events. Both forms are equally valid, each requiring special skills on the part of the photographer.

Formal portraits When photographing formal portraits indoors, the four areas to consider are lighting, background, pose and expression.

LIGHTING AND EQUIPMENT

The simplest and often the best form of lighting is natural daylight from a nearby window. The soft, diffused daylight is excellent, but if the light is a little harsh, then net curtains or some other diffusing material fastened over the window will soften it. Having the sitter facing the window will result in a uniformly lit but flat appearance. Reverse the sitter and the sun will provide an attractive halo around the hair (a technique often used by professionals), but the face will require some extra light from either a free-standing tungsten light or a little fill-in flash. Placing the sitter at around 45° to the window light results in excellent modelling, but again, some fill-in light may be necessary if the shadows are too dark.

One of the most attractive arrangements for portrait lighting is to place the main light 45° to the side and 45° above the sitter, with a less powerful light at face level to lighten up the shadows. This is the traditional, tried-and-tested arrangement, but you may need to use the tungsten setting on the camera to remove the yellow cast. Electronic flash could also be used – the slave flash unit will be triggered by the inbuilt flash on the camera.

It is difficult framing your subject using a handheld camera, so it is worth using a good tripod. Set up the camera and tripod exactly as you want it, releasing the shutter using a cable release (if you have the necessary camera attachment).

This is the basic set-up for a portrait using daylight from a nearby window, with just sufficient diffused daylight on the left side not to require any fill-in lighting.
APERTURE PRIORITY, F/3.5 AT 1/25 SEC, ISO 100, TRIPOD.

- **Flash brollies**
 If you want to go a stage further and create an even more professional finish to your photographs, you could invest in a couple of inexpensive flash brollies. These come in white, silver or gold. Firing the flash into the brolly produces a spread of softer light, equal to the area of the brolly.

High-key and low-key images are at the extremes of portrait photography. The former is all about light, fresh and subtle tones with no dark shadows. This can be achieved using a white background and a white reflector card held by the sitter at around 45° to the main light to lighten the shadows. The nearer the white card is to the sitter, the greater is its effect. In low-key portraits, dark tones and shadows against a black background predominate, achieved using a very dark background and a black card to stop the ambient light being reflected onto the dark side of the face. The results are often quite dramatic and pensive.

For both high- and low-key portraits centre-weighted exposure metering will produce the best results, although the exposure can always be altered by half or one stop if you are not satisfied with the preliminary results.

For head and shoulder portraits never use the standard wideangle zoom setting as it will produce facial distortion. Using a mid-zoom setting and a wide aperture will isolate the subject and throw the background out of focus. If your camera does not have aperture/shutter priority, the portrait setting should produce similar results.

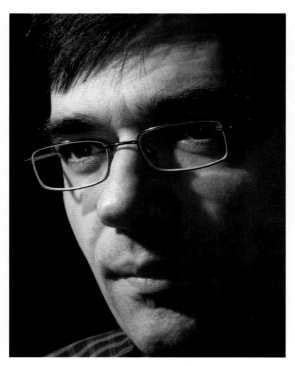

Low-key portrait. A halogen lamp provided the main lighting, with a black board helping to further reduce detail in the shadows. A piece of black velvet was held behind the sitter.
APERTURE PRIORITY, F/4.8 AT 1/3 SEC, ISO 100, TRIPOD.

The set-up used for the photograph on the left. The black velvet background is supported on a cane; the desk lamp with 'snoot' provides extra backlighting.
APERTURE PRIORITY, F/3.5 AT 1/5 SEC, ISO 100, TRIPOD.

BACKGROUNDS

The background should be uncluttered and non-eye-catching – a plain wall is a good starting point. Using a medium zoom setting allows you to crop out unwanted distractions; using a large lens aperture will throw the background out of focus so it will not compete with the sitter. This would be particularly important if the only background available were a lightly patterned wallpaper.

Professional portrait photographers use special studio backgrounds made of cloth, which have a pleasing mottled or cloudy finish and a darker area around the outside, providing the portrait with a natural frame.

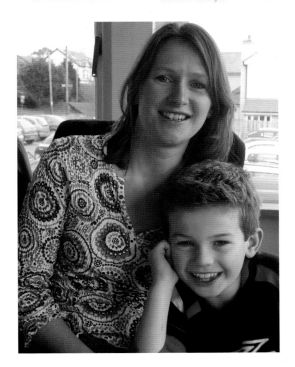

Well-diffused daylight provides some soft modelling. A wider aperture might have thrown out of focus the rather intrusive window frame.
PROGRAMME, F/5.6 AT 1/60 SEC, ISO 100, HANDHELD CAMERA.

POSITIONING THE SITTER

For a head-only portrait, sitting the subject on a low-backed chair with the hands folded on the lap is a good way to start. Arrange the lighting – whether it is natural or artificial – in the 45° position mentioned before – see page 87. Set up the shot so that the head is turned slightly to one side but with the eyes looking at the camera.

For head, shoulder and upper body portraits, settling the subject at a table with the forearms horizontal and the fingers almost touching the elbows results in a strong triangular composition; this is very effective for a manly portrait.

If there are two sitters, it looks much better if one head is slightly lower than the other. With three people, the heads should be at slightly different heights, with the highest just off centre. If children are included in the portrait, you will create a more harmonious image if the children are at the front, sitting on low stools or cushions.

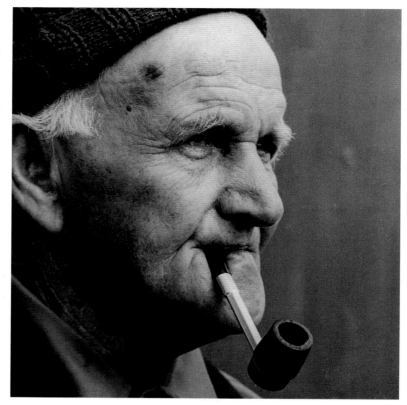

An 'old salt' having a quiet smoke beside his fishing boat. This type of portrait, reflecting a hard-working life, lends itself well to black-and-white or sepia treatment. APERTURE PRIORITY, F/8 AT 1/130 SEC, ISO 100, HANDHELD CAMERA.

CAPTURING THE EXPRESSION

We now come to the final component that will make or break the portrait photograph – the expression. You cannot expect interesting facial expressions without some input from you, the photographer, which is why at this final stage you should not be preoccupied with the camera or lighting. Many adults are embarrassed about being photographed and either look quite vacant or put on a forced smile. Talk to the sitter(s) about their hobbies, the weather or politics – anything that interests them – and look for a natural smile or a thoughtful, reflective or quizzical expression.

This shot, taken in the owner's garden, was lit by natural daylight with a little backlighting to highlight the hair and separate the right shoulder from the background. Looking at the camera and smiling seemed quite appropriate for this type of portrait. APERTURE PRIORITY, F/11 AT 1/60 SEC, ISO 100, TRIPOD.

Arrange the same sort of camera and lighting set-ups discussed on page 86. You will then become an intelligent bystander, watching the sitter and taking shots as and when appropriate.

Informal portraits

INDOORS

It is important to have the sitter doing something, possibly involved with their hobby or interest, such as playing the piano, reading a book, working at a computer or playing chess. Set up the camera slightly to one side and ask the sitter to continue with their activity. Take one or two shots and then mention their name. As they look up, make another exposure or two. No special background is required for this type of photograph. You can try handholding the camera, which gives you more freedom, but, unless you are using fairly strong lighting or a high ISO setting, the longer shutter speed and possible camera shake might result in a slightly blurred image.

OUTDOORS

Taking photographs outdoors, such as in the garden, you should hopefully have a choice of suitable backgrounds. The lighting would be sunlight, ideally slightly diffused but still producing directional lighting. A fill-in for the shadows might be required; this could be a white reflector or possibly flash, set at its lowest setting.

For outdoor photographs you could try handholding the camera, as light levels are likely to be reasonably high and shutter speeds quite short. If including some of the background, a short/medium zoom setting and a moderate aperture would be appropriate. If the background is unimportant, a long zoom setting and a wider aperture will throw the background out of focus, allowing the eye to concentrate on the subject. As we are concentrating on a fairly centrally placed sitter, a centre-weighted exposure reading would produce a well-exposed image.

A quickly posed shot of two youngsters in a carnival. This shot was taken on a sunny day in the shade, resulting in better modelling than would have been provided by flash.
SHUTTER PRIORITY, F/5.6 AT 1/250 SEC, ISO 200, HANDHELD CAMERA.

Again it is vital to have the sitter usefully occupied, for example gardening, bird-watching, or cleaning the lawnmower. Quietly and as inconspicuously as possible, watch the subject at work and take a few shots, occasionally calling their name and pressing the shutter button as they look up. Talk to them and take a few shots as they listen to you.

Children can be rewarding, exasperating, frustrating, coy and *Children* attractive, all rolled into one. They are completely unselfconscious and often have their own agenda. All children need something to occupy them while the session is in progress.

Patience is a basic requisite when photographing children and it's essential not to feel pressured for time. As you are using a digital compact camera, take as many shots as the memory card will hold, deleting the failures later. Shoot with and without flash, at various zoom settings and at the lowest appropriate ISO setting.

A weekend away in the caravan but homework still has to be done. The ambient light provided the main lighting, while daylight from the larger window produced a backlighting effect, plus attractive modelling.
APERTURE PRIORITY, F/8 AT 1/30 SEC, ISO 100, HANDHELD CAMERA.

Close examination of new toy.
PROGRAMME SETTING, F/3.2 AT 1/60 SEC, ISO 100 WITH FLASH, HANDHELD CAMERA.

BABIES AND TODDLERS

Place the baby on a pretty rug surrounded by toys, letting their mother amuse them, while you hover around with the handheld camera set at medium/long zoom and with the flash switched on, ready to take any opportunities as they arise. Older toddlers are always on the move (unless asleep!) and must also be given something to occupy them – a toy, building bricks or colouring book. Or, try sitting them at a child's table – this can often be a useful way of settling them down. You might be able to use ambient daylight if it is sufficiently bright, otherwise the built-in flash is the best alternative. Setting the camera on a kids and pets setting will be a good way to start, although the camera, in its infinite wisdom, will decide on an appropriate ISO setting. To control the ISO level, use either aperture/shutter priority or the programme setting.

TEENAGERS

Teenagers are a strange breed; growing rapidly, they can be embarrassed to be photographed and are generally none too cooperative. Treat them sensitively and with respect, trying to hold their attention by discussing their interests and hobbies. Go with the flow, as trying to organize them too much is usually counterproductive.

CHILDREN OUT AND ABOUT

Children are inherently very active and therefore need something to occupy them in the park or garden. Playing in a pool, on the swings or the slide are obvious examples. Photography often works better if there are two children; they take turns and are keen to compete with each other. Study the action and decide where a good shot would be, focusing on this spot either by taking the first pressure on the shutter button or setting the focus on manual.

If you are photographing children on swings it is worth remembering that at the height of the swing's movement, it is for a split second motionless. Not only is this the best moment to take the photograph, it also produces the most dramatic image. If you have a choice, select a short shutter speed of 1/100 sec or

slower and an ISO setting of 200–400. A kids and pets setting will automatically select a wide aperture, a short shutter speed, a high ISO setting and automatic flash.

And remember, when taking any portrait photographs always keep in mind the composition of the image, as this can make the difference between an average shot and a really outstanding one.

It was not too difficult to get a pleasing shot as the children take a break from climbing about on a fallen tree. PROGRAMME, F/5.6 AT 1/120 SEC, ISO 100, HANDHELD CAMERA.

STILL-LIFE

11

TYPICAL EXAMPLES OF still-life shots would be those featuring a bowl of fruit or an arrangement of flowers. Still-life photography does not seem to be very popular with photographers, possibly because apart from examples taken from nature, such as pebbles on the seashore or a carpet of frost-covered autumn leaves, all still-life materials must be collected, arranged and lit by the photographer. This work calls for time, patience, skill and a little imagination.

Professional still-life photographers often spend days in their studios arranging and lighting the materials to perfection, rejecting all but the most perfect examples of whatever they have been commissioned to photograph. The results usually appear as adverts or illustrating articles in the glossy magazines. Although a photograph is captured in a split second, we, as keen amateurs, need to spend a substantial amount of time arranging and lighting the material if we are to produce a worthwhile result.

Essentially there are two types of still-life subject: those that are three-dimensional, as in a bowl of fruit; and flat, two-dimensional graphic design subjects, such as an arrangement of coloured pencils or a display of coins on a black background.

Sea-urchin shell illuminated from within. Macro-setting.
APERTURE PRIORITY, F/8 AT 1/10 SEC, ISO 100, TRIPOD.

Brain coral lime skeleton.
APERTURE PRIORITY,
F/11 AT 1/125 SEC,
ISO 100, TRIPOD.

COMPOSITION AND COLOUR

Three-dimensional still-life

Composition is the way we group the various elements of the still-life to produce a unified whole. The main focus of interest should not necessarily occupy the centre of the picture, because after a while this arrangement could become rather boring to the eye. It is best placed off centre, about one-third from the edge of the frame and a similar distance down the frame. Take a bowl of fruit, for example: it will need to be counterbalanced by something towards the other side of the frame image. A small but prominent object positioned towards one side of the picture should be balanced by something on the other side that could be larger but less demanding on the eye. This applies particularly to coloured objects, where a small, densely coloured item can be balanced by one which is much larger but of a weaker colour.

When assembling several objects to build up a still-life image, which is itself a difficult exercise, err on the side of simplicity. Be mindful of colours that harmonize with each other, such as the yellows and browns in autumn leaves, and those that clash like orange and pink. Greens are restful colours, while red is a vibrant, exciting colour and blue is clean and tranquil, as exemplified by blue sky and clear blue water. A still-life study may have a single, overriding colour supported by subsidiary blending colours, but be wary of using a mixed palette of strong primary colours.

Cross with shadow
– side-lit against
curved white
background.
APERTURE PRIORITY,
F/6.3 AT 1 SEC,
ISO 100.

Backlit shot against
dark background,
highlighting the
detail in the curved
extensions.
APERTURE PRIORITY,
F/6.3 AT 0.5 SEC,
ISO 100.

Close-up of two sections of the cross forming the base and side support for the image, balanced by the curled wood at the other side. APERTURE PRIORITY, F/8 AT 1/20 SEC, ISO 100 −1 STOP.

LIGHTING

The quality of the light is vitally important – whether it is flat and shadowless, low key or high key, it must be in sympathy with the subject being photographed. Rather than spend a fortune on studio lighting, start with what is readily available in the home. Daylight from a window will provide directional lighting, which might be exactly what you require. If it is too directional or too harsh, it can be softened by pinning a sheet of tracing paper over the window. If the shadows are too dark, a white card or crumpled silver foil reflector will direct light into the shadows. You could try using a portable study lamp with a quartz iodine bulb as either the main light or subsidiary light. Working in the evening without the advantage of daylight, two such lamps should provide the right amount of modelling. A little backlighting could also be tried.

It is also worth considering using the camera's built-in flash either 'naked' or covered with a piece of translucent plastic. Alternatively, try holding a sheet of tracing paper about 40in (1m) from the still-life material and firing the flash through it.

BACKGROUNDS

The colour and type of background need careful consideration as they can make or mar an otherwise successful picture. The background should harmonize with the still-life material: simple, uncluttered backgrounds work best. To avoid including the distracting line between the table top and the background, you can either raise the material and shoot horizontally, use a long table and tilt the camera down slightly, or bend a background card to form a smooth curve near ground level. All professional studio photographers use curved backgrounds, including the huge ones required when shooting new car adverts – which are still-lifes, but on a grand scale!

I have several large sheets of cardboard in a range of solid colours, including some that have been mottle-sprayed in harmonizing colours. However, depending on your subject, all kinds of background materials can be utilized, including sand, tiles, wallpaper, black perspex, sackcloth, canvas and so on.

Two-dimensional still life The photography of two-dimensional graphic design can be based on random or organized patterns, spirals, curves or circles and can be found in nature or be man-made.

Whether the still-life material is assorted shells on the seashore, lichens growing on flat stones or simply an item of jewellery on a piece of black velvet, they are best photographed from above, often with overhead lighting. However, side-lighting will enhance surface texture and, because of the flat nature of the subject, any edge shadow will be quite limited.

Section of Golden Emperor moth wing.
MACRO SETTING, F/11 AT 1/5 SEC, ISO 100, TRIPOD.

Underside of barn owl feathers, with interesting lines and harmonizing colours.
APERTURE PRIORITY F/16 AT 1/4 SEC, ISO 100, TRIPOD.

CAMERA SET-UP

Because still-life material is static and you tend to work quite close to it, use a camera support and accurate manual focusing. Unless you prefer a more abstract image, with large areas out of focus, then a well stopped-down lens aperture will produce an increased depth of field; however, this is only possible if your camera has an aperture priority mode. If not, then use programme mode, leaving the camera to select the appropriate lens and shutter settings.

In addition to using a tripod for camera stability and to allow manual focusing, it would be beneficial to employ a shutter delay of at least 2 sec to avoid disturbing the camera with your fingers. Finally, I would suggest a low ISO setting for sharp, smooth images and centre-weighted metering for a well-exposed image.

NIGHT-TIME

AS DAYLIGHT BEGINS to fade and the last sunset images have been captured, most photographers will pack up their equipment and head for home. That's fine, but why not have a meal and then go out again, complete with camera, and attempt some night shots? Your digital compact camera is capable of capturing excellent night photographs of a variety of subjects ranging from floodlit buildings, shop windows and Christmas markets to outside cafés in your favourite holiday resort and firework displays. You can travel light, with just your camera and a camera support.

Funfair at night. The camera was swung with the motion of the roundabout, thereby producing a sharp image. PROGRAMME, F/3.2 AT 1/50 SEC, ISO 100, HANDHELD CAMERA.

A floodlit building photographed at just the right time in the evening can make a very striking picture. Arrive around sunset, reconnoitre the area, study the traffic conditions and find a suitable location so that the building looks at its best with strong composition.

For the photograph above, I set up my camera and tripod one Sunday evening on the pavement opposite the town hall. Not wanting to include any red and white traffic trails, I studied the traffic lights, working out when there would be a lull in the traffic. Within half an hour the light had changed from an evening glow to total darkness. Of the half-dozen shots I had taken, one was exactly what I wanted, with the town hall nicely lit and silhouetted against a velvety blue sky. A group of people stopped to chat and by the time they departed, the sky was completely black, so I packed up and followed suit.

Buildings

The town hall in Leeds, UK, on a winter evening. Ten minutes after taking this shot the sky was completely black. I watched carefully for a break in the evening traffic.
PROGRAMME, F/5.6 AT 0.8 SEC, ISO 200, TRIPOD.

Exposure, using the programme setting, was f/5.6 at 0.8 sec on ISO 200. A night scene setting could also have been employed but this would have used the highest ISO setting – which is all right for a handheld shot but rather pointless if you are using a tripod and could choose a low ISO setting, reaping the benefits of fine detail and lack of 'noise'. Evaluative metering would be used for all shots.

Christmas lights, with the wet road providing extra reflections.
APERTURE PRIORITY, F/3.5 AT 1/4 SEC, ISO 80 –1 STOP, TRIPOD.

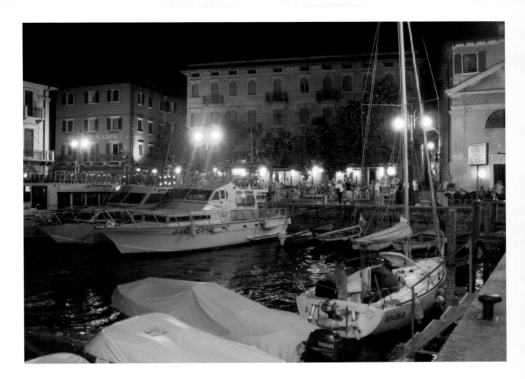

On holiday you are probably not prepared to take a tripod out with you at night (or even during the day!). If you are staying in an area for a few days, check the location during the day to establish a good shooting position. The small but busy harbour in the holiday resort of Malcesine in Italy looked very promising. A photograph taken during the day recorded an exposure of f/8 at 1/300 sec on ISO 80 – such was the overall brightness of the location. For the night shots the camera was set for night scenes resulting in an exposure of f/2.8 at 1/8 sec on the highest ISO setting of 400. This setting put the flash on 'automatic' and, although it fired, its effect was negligible, with nothing sufficiently close to be affected by it. Lacking a tripod, the camera was braced against a lamp post, which was fine for a 1/8 sec exposure. If you have a tripod, you could abandon the night scene setting. Select aperture priority or the programme mode, thereby allowing the use of a lower ISO 80 setting, which will result in a sharper, more detailed image.

Holidays

Malcesine harbour, Lake Garda, Italy. The camera was braced against a lamp post. PROGRAMME, F/2.8 AT 1/8 SEC, ISO 200, HANDHELD.

Fireworks and bonfires For bonfire shots, a night setting would be appropriate as this includes the flash but increases the exposure to capture some of the background detail. As the ISO setting will be at its highest level the camera can be handheld with only a minimal chance of camera shake. Switch off the flash and you could capture intriguing silhouettes of people gathered around a bonfire.

Taking photographs of fireworks exploding in the night sky calls for a completely different approach. Ideally you will want an inky black sky with no light pollution. From my kitchen window I suddenly saw some fireworks exploding in the sky and quickly grabbed my digital compact, set it on the fireworks programme and attached it to a small tripod. Out in the back garden the tripod and camera were wedged on top of a wooden fence, pointed to where the rockets were exploding, while I set the zoom to produce a reasonably large image. Fortunately more rockets were launched and I managed to capture several bursts of colour. On my camera the fireworks setting is f/8 at 2 sec, which seemed to produce just about the right exposure.

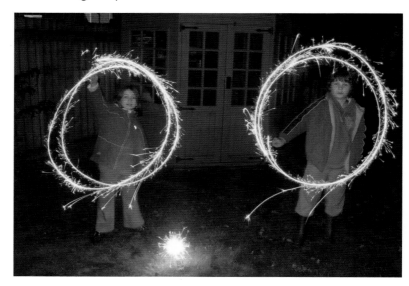

Children with fireworks. A long exposure with just a little flash to capture the children's arms. The off-the-camera flash unit was triggered manually. SHUTTER PRIORITY, F/2.8 AT 1.6 SEC, ISO 100 −1STOP UNDEREXPOSURE, TRIPOD.

An alternative method is to set up the camera on a tripod and, using shutter priority (if available), set it for a long exposure (15–30 sec). Hold a piece of black card over the lens and release the shutter. As a rocket is launched, uncover the lens and hopefully catch the burst of colour. Cover the lens immediately and wait for the next firework launch. Using this method you can capture several explosions on the same picture but you may have to adjust the lens aperture and ISO setting to produce a correctly exposed image.

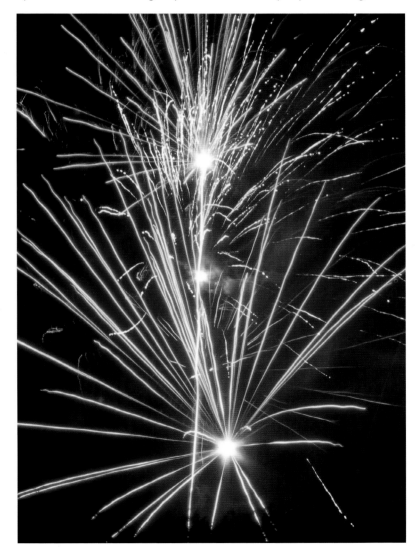

Exploding fireworks. The camera was wedged on the top of the garden fence and handheld. FIREWORK SETTING, F/8 AT 2 SEC, NO RECORDED ISO SETTING.

SPORT

13

GREAT SPORTING EVENTS have yielded some of the world's most exciting images, as exemplified by the excellent photographs in newspapers and sports magazines.

This is definitely a specialist field for the photographer, requiring lots of patience, experience and sharp reflexes. A knowledge of the sport you intend to photograph is vitally important; if you are not familiar with it, a visit to at least one match or event is essential. This will enable you to familiarize yourself with the movements of the players and where to capture the most exciting shots. Several important matters must be addressed before we get down to the details of how to photograph various sports. These include camera shake, subject movement, shutter delay and backgrounds.

Camera shake A zoom lens brings with it the problem of camera shake; this means that for a modest 6x zoom, giving a focal length of about 200mm, the slowest shutter speed using a handheld camera would be 1/200 sec. Similarly a 10x zoom (focal length approximately 360mm) would require an exposure of 1/360 sec. Due to the speed of the sporting action, an in-built image stabilizer would be an obvious advantage and this is becoming much more common on the latest digital compact cameras. High shutter speeds are readily available on shutter priority cameras but more difficult to obtain using the programme setting, unless a sports mode is available. One way round the problem is to select a high ISO setting of 400–800.

Subject movement Subject movement is an obvious characteristic of sporting activities and, unless you particularly want some blur in the images, a high shutter speed is essential to 'freeze' the sportsman's movements and produce a sharp photograph. A person moving across the frame of a static, handheld camera requires a much higher shutter

speed to freeze the movement than if the person was coming directly towards the camera. Although this high shutter speed is essential, it can be greatly reduced by swinging the camera (this is called 'panning'), thereby keeping the subject almost static in the viewfinder or LCD screen.

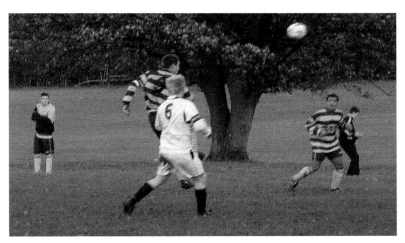

Soccer is a fast-moving game; in this shot, the ball has just been headed but is still visible, with the player captured in mid-air. SHUTTER PRIORITY, F/3.5 AT 1/320 SEC, ISO 200, HANDHELD CAMERA.

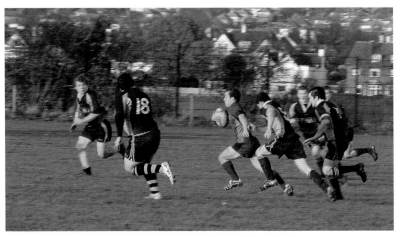

A rugby match in full swing, with the ball being carried forward and the defenders giving chase. This image has been cropped. SHUTTER PRIORITY, F/4.8 AT 1/300 SEC, ISO 200, HANDHELD CAMERA.

Slow autofocusing One of the biggest problems associated with photographing sport, particularly fast-moving activities, is shutter delay, related to the time taken for the camera to focus accurately on the subject. Shutter delay can vary from 0.2 sec to almost 1 sec but, fortunately, there are various ways of coping with the problem. Try using the manual focus setting, pre-focusing on the spot where the action is likely to take place; or line up the target area and take the first pressure on the shutter button, releasing it as the action takes place. You could also try continuous focusing and the rapid shooting setting (using a super high speed memory card).

Backgrounds At any sporting venue the background, such as a building or other spectators, can be a distraction, often spoiling what would otherwise be a good picture. Ways to avoid this include changing your shooting position, or using a wider lens aperture to throw the background out of focus. You could try zooming in to fill the frame with your subject, or cropping the image later to produce much the same effect. Panning the camera should result in a sharp image against a streaked, blurred background.

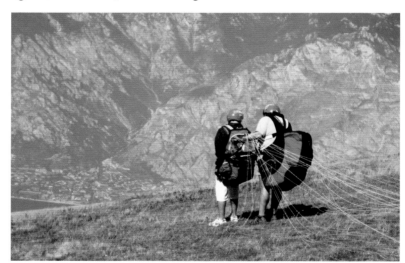

Two paraglide enthusiasts in tandem just before their running launch from the summit of Monte Baldo, Italy.
PROGRAMME, F/10 AT 1/400 SEC, ISO 100, HANDHELD CAMERA.

Studying sports photographs in any newspaper or magazine will reveal the most exciting types of shots and where they were taken. For example, as the aim of a soccer match is to score goals, it is therefore not surprising that all the professional photographers assemble along the goal line. You can pre-focus on the goal area ready to capture what I refer to as 'confusion in the goal mouth'. Similarly, when a player takes a corner kick or penalty you can focus on the goal area, which is where the action is likely to take place. Good mid-field shots are more difficult to capture as the players are usually too far away and their movements can often appear erratic. In rugby, line-outs or scrums are relatively easy to photograph because they begin from an almost static position. A tackle, or a player sliding over the line with the ball can result in a very exciting photograph. Much the same advice applies to action in other ball games, such as American football.

Paragliding enthusiasts launch themselves into the sky either by jumping off a precipitous edge or running down a steep incline into the wind. They are kept aloft by upcurrents of air. Good shots are easily obtained at take-off or in mid-air if they are sufficiently close.

Selected sporting activities

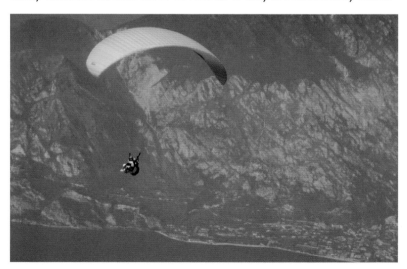

Finally airborne. PROGRAMME, F/10 AT 1/400 SEC, ISO 100, HANDHELD CAMERA.

Water sports such as canoeing, kayaking and rowing provide excellent photographic opportunities and you can usually get quite close to the action. To 'freeze' it, an aperture/shutter priority camera would be ideal, allowing a short exposure of at least 1/200 sec. Otherwise use the Kids and pets setting if your camera has one. A high ISO, of at least 400, would also be helpful.

In swimming there are two types of shot that are easily achieved if you have access to the pool-side. Either choose a very short exposure and 'freeze' both the swimmer and the turbulent water, or use a longer exposure and pan the camera as the swimmer passes you, keeping the swimmer in sharp focus but allowing the background to blur. Another good photo opportunity is when the swimmer is coming towards you. This does not require a high shutter speed and could be taken on the programme setting using a fairly high ISO number. A long zoom lens is not required for any of these shots as the swimmers should be quite close to you.

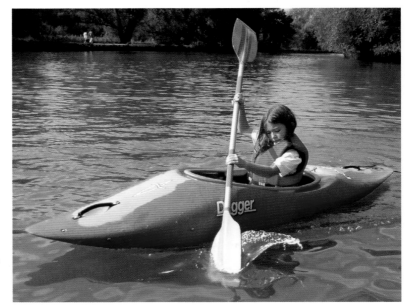

An easy shot to take on almost any setting, although a short exposure would help to 'freeze' the water on the ends of the paddle.
APERTURE PRIORITY, F/4.5 AT 1/200 SEC, ISO 200, HANDHELD CAMERA.

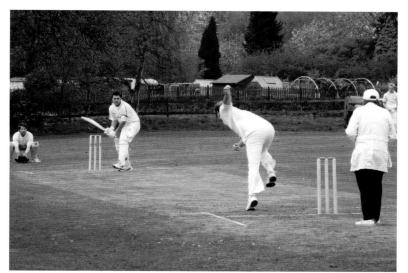

Ball delivered by the bowler with the batsman ready to strike. The ball is 'frozen' in space just above and to the left of the bowler's head. A dull cloudy day was ideal to capture some detail in the highly reflective white shirts and trousers. SHUTTER PRIORITY, F/5.6 AT 1/800 SEC, ISO 400, HANDHELD CAMERA.

In cricket, the batsman provides the main interest, remaining stationary until he actually strikes the ball. Racing to the crease as the wicket-keeper catches the ball and swipes off the bails can also provide a good photo opportunity. This applies equally to games such as baseball and rounders.

In tennis, potentially good shots can be created when the server throws the ball up into the air prior to smashing it across the net. Capturing the moment just after the racquet has made contact with the ball is much more difficult because of the speed of the action, but well worth trying. Finally, a player defending at the net and launching himself horizontally at the ball would make a fine image.

Because of the pace of the action, sports photography is a difficult subject for the amateur photographer to tackle, requiring lots of patience, skill and anticipation. However, much good work can be done using a digital compact with a modest zoom range. All the images included in this chapter were taken using a digital compact camera with a 6x zoom lens, and centre-weighted metering on ISO settings ranging from 200 to 400.

TRANSPORT IN ACTION

14

Waterbus clears
the Rialto Bridge in
Venice, Italy.
PROGRAMME, F/7.1
AT 1/250 SEC, ISO
80, HANDHELD
CAMERA.

THIS CHAPTER CONCENTRATES on photographing movement (as
static cars, aeroplanes and so on can look rather boring). Diffused
lighting is recommended, as very bright sunlight provides too
much contrast, causing hot spots on the shiny metallic surfaces
of vehicles and blocked-up shadows. A polarizing filter will reduce
unwanted surface reflections and will also boost colour saturation.
The programme mode, coupled with a medium/slow ISO setting,
on a handheld camera would be a good starting point.

Transport by gondola on a hot sunny afternoon in Venice. The gondola is diagonally positioned, suggesting movement; the darker foreground forms a suitable base to the picture. PROGRAMME, F/5.6 AT 1/250 SEC, ISO 80, HANDHELD CAMERA.

Boats

A ferry or waterbus moving slowly towards the landing stage, or a gondola full of sightseers gliding by, both provide pleasing photo opportunities. These photographs were taken on a bright day with the camera handheld, in the programme mode and on an ISO 80 setting. For both images, I worked out the composition before the waterbus and gondola docked.

A speed boat can often provide an interesting photo opportunity. Rather than photographing it as a static, moored boat, try taking some action shots as it speeds across the lake or river, churning up the water in its wake. The picture often looks more satisfying from a composition viewpoint if the boat is approximately one-third into the frame leaving space ahead for it to move into. A high angle shot taken from a ferry or cliff top, with the boat surrounded by clear blue water, seems to produce a more attractive image than one shot at ground level.

Motorbikes

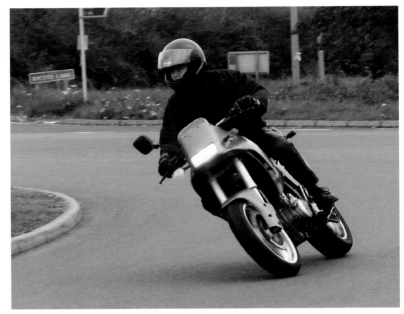

Motorbike in action. After several circuits of the roundabout this proved to be the best shot. Without the lean of the bike there would be no impression of speed.
APERTURE PRIORITY, F/3.5 AT 1/60 SEC, ISO 100, HANDHELD CAMERA.

A motorbike in action must have plenty of lean on it to engender a feeling of excitement and speed. This is not too difficult to achieve on pubic roads if you choose a bend or roundabout. The photograph illustrated was taken one quiet Sunday morning with the motorcyclist circling a fairly large roundabout several times. I followed him on the LCD screen, applied the first pressure and released the shutter at the appropriate moment.

The best places to photograph real action are fast road circuits, that have both fast and slow corners and plenty of undulations. Looking straight into an 'S' bend you might be lucky and catch the lead rider leaning over with his knee protector just grazing the road, while the rider behind is leaning the other way. For these shots a fairly fast shutter speed of 1/300–1/500 sec would be appropriate, with centre-weighted metering. Alternatively, use the programme mode and a higher ISO setting (200–400) to shorten the exposure.

A moving car looks very static if photographed head-on, travelling towards you on a straight road. However, the same car, leaning over as it comes out of a fast bend, can look quite impressive. Another option is to follow the car on the LCD screen, using a smooth movement, pressing the shutter as the car passes but continuing the panning movement. Employing a slow shutter speed of around 1/30–1/60 sec can result in a sharply defined car against a horizontally striped, blurred background.

Photographing a racing car at speed with a digital compact camera is quite difficult; you cannot get sufficiently close to the track because of the very wide run-off safety areas and, let's face it, these cars are going incredibly fast. However, you could try photographing the cars as they slow down and peel off into the pit lane. Camera requirements would include a long zoom, a short exposure, a medium ISO setting, centre-weighted metering and a tripod or monopod for extra stability.

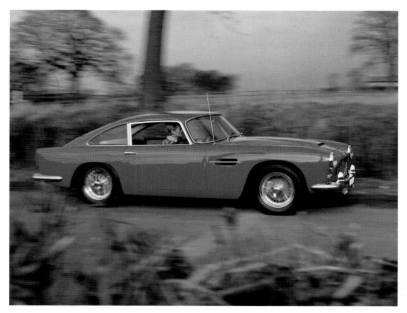

Aston Martin at speed. By swinging the camera as the car passes, the background registers as a blur, while the car is pin-sharp.
SHUTTER PRIORITY, F/11 AT 1/60 SEC, ISO 100, HANDHELD CAMERA.

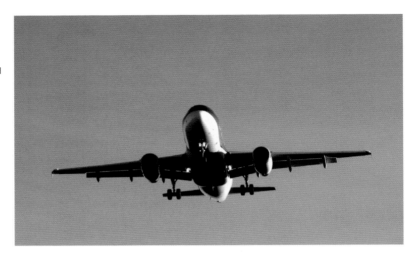

Aircraft about to land with lights switched on, landing wheels down and the wing flaps extended into the landing position. Image taken about ½ mile from the end of the runway. SHUTTER PRIORITY, F/5.6 AT 1/500 SEC, ISO 100 UNDEREXPOSURE −0.3 STOP.

Aeroplanes To have any impact, an aeroplane should be in flight rather than sitting on the apron like a beached whale. My favourite type of shot is of a plane coming in to land, flying towards me with the landing lights switched on and the wheels lowered. The difficulty is finding a camera position in line with the runway and as near to it as possible. As the aircraft is coming towards you relatively slowly and with little obvious movement, the normal programme mode and an ISO 100 setting would be fine. A longish zoom (6x) is preferable and I always use a monopod for extra stability.

Taking shots of fly-pasts at an air show is even more difficult than photographing Grand Prix cars in action, as the aircraft emerge from all points of the compass, at different heights and at varying distances from the spectators. The best way to photograph them is to follow the aircraft in the camera viewfinder (or LCD screen), release the shutter as the aircraft passes but continue the smooth panning action. Keep the exposures short; use a fairly high ISO setting (around 200–400) and handhold the camera to allow complete freedom of movement. Against a bright sky the aircraft will tend to register as a dark silhouette so will require one or two stops more exposure than the meter suggests.

You will find there are still many steam trains in regular service, manned by professional and amateur enthusiasts. The most appealing type of shot is a three-quarter view of a moving train belching out smoke or blowing off steam. Using a local map you can follow the route of the railway, looking for a suitable photo location. Try photographing the train as it slows down at a level crossing before crossing the main road.

Another good photo opportunity would be an engine labouring up a gradient with smoke billowing backwards along the full length of the train. Set the camera on programme mode (or with the lens partially stopped down on the aperture priority setting) with evaluative metering and a low ISO number for maximum detail. I would suggest using a monopod to steady the camera.

Steam trains

The Moorlander steam train, making smoke and venting steam as it labours uphill.
Shutter priority, f/4.5 at 1/160 sec, ISO 100, underexposure −0.3 stop.

PETS

15

PETS ARE IMPORTANT members of the family, playing a significant role in the lives of their owners. It is therefore not surprising that we take lots of photographs of them.

Dogs and cats indoors

You could begin by photographing your pet in a typical everyday location. If it spends a lot of time asleep in its favourite chair or basket then take initial shots from that position. Photographing an undisturbed pet does not require any special camera settings. Use aperture/shutter priority or the programme mode, centre-weighted metering and a low ISO setting with the camera handheld and the flash switched on. Use a medium zoom lens setting to avoid getting too close to your pet and disturbing it.

To capture an alert dog you will need to catch its attention. Name calling, clicking your teeth or simply making silly noises should all work. It is helpful for another person to take on this task while you line up the image on the LCD screen. Using a medium zoom setting (around 60–70mm) will produce a decent sized image while allowing you to keep a reasonable distance from the subject. A fairly wide aperture will throw the background out of focus, although the depth of field will be quite small.

Classical portrait of Cavalier King Charles spaniel puppy against a rich, subdued background. Two flash units were used – a main frontal light and a slave unit above and behind.
APERTURE PRIORITY, F/11 AT 1/60 SEC, ISO 80, TRIPOD.

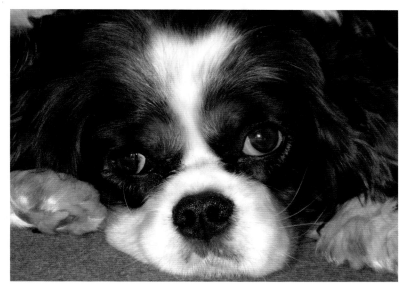

Holly, relaxed on the floor but still keeping a close eye on me. PROGRAMME, F/7.1 AT 1/60 SEC, ISO 100, FLASH, HANDHELD CAMERA.

PET PORTRAITS

As with human portraits, keeping the eyes in sharp focus is essential as this is the first thing we look at. Some digital compact cameras include a centrally located autofocus frame which can be aligned with your pet's eyes. After taking the first pressure on the shutter button to lock the focus, re-align the image if necessary, and fire the shutter. Otherwise let the camera take the strain, as it were, hoping that in its infinite electronic wisdom it manages to keep the eyes in sharp focus.

A moderately wide aperture would be fine for a fairly flat-faced dog such as a King Charles spaniel or a Pekingese, whereas a long-nosed dog like an Afghan hound or an Irish setter would require a more stopped-down lens (increased depth of field) to keep both the eyes and nose in focus. An alternative to a full-face stance is a partial side-view, thereby lessening the effect of the eyes and nose distance problem.

While lining up the image on the camera's LCD screen keep in mind the composition of the picture, in particular the rule of thirds and the general balance of the major components. If your pet lies down on the floor, then so should you; not to show solidarity but to create a more intimate image.

THE SET-UP

For photographing dogs, the camera can be handheld with the flash switched on, providing safe frontal lighting. If you want to be a little more adventurous, placing a small slave flash behind and to the side of the dog would result in a more attractive portrait, with some of the dog's coat pleasingly highlighted. This lighting arrangement is particularly useful if your dog has a black coat. Finally, you need to consider the colour of the dog, what it is sitting on and the background colour. A black or dark background allows the dog to stand out in an impressive way.

All of these points apply equally to photographing cats. A cat asleep in its basket would be a good way to start. Later, to catch the cat's attention, your assistant could try dragging a piece of string across the carpet. Your cat, particularly if it is black, would benefit from the slave flash backlight described above.

It is also worth remembering that a black cat or dog would give an inaccurate camera meter reading (too long an exposure), rendering your pet washed-out black. Underexposure of one or more stops should solve the problem, while a white-coated pet would require the same amount of overexposure. As always, the image can be checked immediately after taking the shot and any adjustments made before shooting the next frame.

Tommy the cat looking intensely at a piece of string, dangling out of frame. The important eyes are in sharp focus.
APERTURE PRIORITY, F/5.6 AT 1/60 SEC, ISO 100, NO FLASH, HANDHELD CAMERA

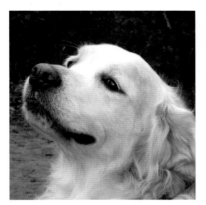

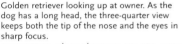
Golden retriever looking up at owner. As the dog has a long head, the three-quarter view keeps both the tip of the nose and the eyes in sharp focus.
PROGRAMME, F/5 AT 1/100 SEC, ISO 200, FLASH, HANDHELD CAMERA.

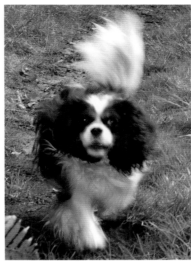
Holly on the move, with her 'flag' flying. Photographed at ground level so as not to diminish the image of the dog.
SHUTTER PRIORITY, F/3.5 AT 1/150 SEC, ISO 200, HANDHELD CAMERA.

A photograph of your dog bounding flat out towards the camera always makes a very attractive photograph. Handhold the camera in the upright position, set a medium zoom on the lens, pressing the shutter button just as the image of the approaching dog is the size you want. You might be lucky, capturing the dog in full flight and in focus, but shutter delay usually prevents this happening. It would be better to take the longer route and persuade a friend to hold the dog while you set the zoom for image size. Ask the friend to leave a marker on the ground (such as a twig or a leaf, for example) before retreating down the path with the dog. You focus on the marker (either manually or by taking the first shutter pressure), then the dog can be released and, with some luck and a little encouragement, it will race towards you. Releasing the shutter just as the dog is about to hit the marker should result in a well-framed dog in full flight and in sharp focus.

Many dogs love water, which presents several excellent photographic opportunities. For instance, a close-up of your dog in the water, paddling towards you, could make a good photograph.

Dogs and cats outdoors

However, an even better opportunity will arise as your dog shakes off the water afterwards. If by chance or design the sun is behind the dog and the background quite dark, the water droplets will be beautifully highlighted and you will have produced a classic photograph. Many dogs are good jumpers and 'freezing' it in mid-air as it jumps for a stick always makes an exciting picture.

For all the shots described, the camera could be handled and would require a very short exposure of around 1/250–1/500 sec. If your camera has aperture/shutter priority, there will be no problem; otherwise, use the scene setting for kids and pets, as this will give a short exposure but no control over the ISO setting. In all cases, switch on the flash, which might be useful and certainly can't do any harm. A final idea for an interesting image is to combine a slow shutter speed (1/15–1/60 sec) with a panning shot to create an artistic blur in the background while keeping the dog in focus.

Photographing cats outdoors is quite a different proposition. Indoors, cats love human company but outdoors they are solitary, wandering, hunting animals. The best you can hope for is to photograph your cat sitting on the windowsill or shed roof, watching birds on the peanut holder. The auto or programme mode would be fine, while a medium or long 300m lens setting will produce a large image from a reasonable distance.

So far I have been suggesting medium zoom settings; however, a wideangle setting can be useful if, for some special reason you want to include the background. For example, should you have a large, attractive garden, a wideangle setting would allow you to photograph your pet in the foreground with the garden behind.

Hamsters and gerbils Photographing a hamster or gerbil in its cage is not very aesthetically pleasing, but, as both are desert rodents, why not photograph them in a natural, sandy environment? Fill a shallow fruit box with sand and, for added realism, plant a small cactus seedling. With food (nuts, pieces of carrot) in the box the hamster is usually quite happy to roam around in the sand feeding; even if it climbs out of the box it is easily retrieved. The gerbil is rather more agile and you may have to resort to the aquarium technique

Gerbil feeding, using front legs to push food into its mouth. The gerbil's body is aligned with the camera back to keep it, including the all-important eyes and whiskers, in sharp focus. Two flash units were used – a main frontal and a less powerful overhead unit. APERTURE PRIORITY, F/11 AT 1/60 SEC, ISO 80.

described on page 127 (using an empty aquarium of course!). Use the camera's built-in flash to provide the lighting. I recommend using a remote slave flash positioned above and slightly behind the set-up. The camera should be set for close-ups and handheld for ease in following the hamster. Selecting a small aperture will help to keep all of the hamster in focus but, failing that, the programme setting in the close-up mode would be satisfactory. If possible, use a low ISO setting to ensure crisp, detailed images.

Tropical and cold water fish

Photographing your fish through the front of the aquarium is not difficult if you bear in mind that these creatures are moving in three dimensions. The main problems are keeping them in focus and avoiding unwanted reflections. To produce an acceptably large image you need to work close to the subject, and the depth of field will be very small. You will therefore have to devise some means of keeping the fish within the zone of sharp focus. The best method for smallish fish is to place a glass or perspex sheet, approximately the same length and height of the aquarium, in the water about 2½in (6cm) behind the front surface. This allows the fish complete freedom of movement in two dimensions but limits it in the third dimension. As the volume of water in front of the glass sheet is rather small, it will become depleted of oxygen if several active fish are present, and you should remove it as soon as you have completed the photography.

Unwanted reflections on the front of the aquarium can arise from the immediate surroundings (windows and glass-panelled doors), the camera itself and the source of illumination. The window problem can be solved by blacking out and you can check its effectiveness on the LCD screen. To eliminate reflections of the camera and yourself, take a piece of black card some 10in (25cm) square and cut in it a round hole for the lens barrel and a rectangular hole for the flash window. Fit the card over the lens barrel and check its effectiveness on the LCD screen. Your aquarium is probably already equipped with small pebbles and attractive water plants; if not, it is worth introducing some to obtain a natural and more interesting photograph.

Finally, you might also improve the picture by standing a piece of coloured (or black) card behind the tank to function as a background. Use a small aperture or programme setting, close-up mode, low ISO setting and a handheld camera. All these techniques can be undertaken using a compact digital camera and you can anticipate some excellent results.

The set-up for photographing fish in an aquarium. Note the position of the glass sheet and the curved, supported background.

Glass sheet

Background

LIGHTING

The camera's built-in flash will provide the main lighting, with a supplementary slave flash above the aquarium to simulate sunlight. More powerful frontal lighting can be produced by attaching a small slave flash unit to the side of the camera, while high or backlighting can also be achieved using another slave flash unit. The camera's built-in flash should have no difficulty triggering the slave flash units if you are working in an average-sized room with normal, light-reflecting walls. However, as the slave flash units are not linked to the camera you will have to vary their distance from the subject to obtain the lighting effect you require.

The speed of exposure calculation and focusing carried out by the camera's processor can present a problem (a delay of around 0.3–0.9 sec). Despite your best efforts you should expect several out-of-focus images of your running dog, roaming hamster or swimming fish. However you can take dozens of shots and remove the failures afterwards, bearing in mind your memory card can hold scores of images. The quality of your images is limited only by the depth of your imagination and not by the technical specification or price of your compact camera. So go for it and make your mark!

Two Israeli shabunkins limited by a glass sheet positioned some 2½in (6cm) behind the front surface of the aquarium. Two flash units were used – a weak frontal flash and a more powerful overhead unit. APERTURE PRIORITY, F/11 AT 1/60 SEC, ISO 80, TRIPOD.

WEDDINGS

ANY PROFESSIONAL WEDDING photographer is well aware that a wedding is a one-off occasion which cannot be re-shot. Having been the official photographer at a couple of weddings, in addition to taking photographs at many others, I feel able to outline all the photo opportunities and camera requirements in the sequence in which they normally take place. You will be relieved to know that I do not suggest using a tripod – all the shots can be handheld.

Before the ceremony
Arriving ahead of the guests will allow you to photograph the groom and best man framed by the church entrance or the registry office. Next to arrive will be the bridesmaids and if time permits and the sun is shining very brightly, try to find a suitable shaded area and take a few photographs. Full length portraits are traditional; try a few head and shoulder shots as well, which are good for showing facial expressions.

On no account get in the way of the professional photographer, as he has enough to do without having to cope with pushy amateurs. He will automatically take his photographs in the shade, as a very bright sun will be too 'contrasty', with the likelihood of burnt-out highlights and dark, blocked-up shadows.

Next to arrive will be the bride and her escort and you might be lucky to snatch a shot as the bride is helped out of the car.

For all these shots the camera can be handheld, using the programme mode, evaluative metering and a low ISO setting.

During the ceremony
You may not be allowed to take photographs during the ceremony but signing the register afterwards can provide a good photo opportunity. Position yourself so that the bride signing the register has the groom on one side, with the registrar in the background, all nicely filling the frame. At a church wedding, the bride and groom walking down the aisle after the service always provides an attractive image. Handhold the camera and use the flash.

There are two types of photograph that need to be considered for outside the church or registry office and the reception venue. *After the ceremony* The first involves the more formal photographs of the bridal group, while the second includes informal shots of the guests chatting in small groups after the ceremony or having wine and canapés outside the reception venue.

The official photographer will arrange all the formal groups and again, he will automatically select a shady, pleasant background. You are quite at liberty to photograph his groups but be circumspect and don't hold up his busy schedule by making requests to the groups; take one or two shots and move on. Shoot plenty of informal photographs of the guests as these are very popular, particularly with the bride and groom. Try to keep the groups well within the frame, occasionally using the zoom for head and shoulder shots. Use the programme setting with the flash permanently switched on, because even in fine, sunny weather the flash will always help to fill in any dark shadows.

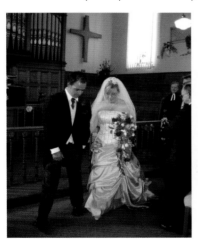

First tentative steps as husband and wife. I was the only photographer to capture the shot as there was no aisle for the couple to walk down. PROGRAMME, F/2.8 AT 1/60 SEC, ISO 200 WITH FLASH, HANDHELD CAMERA

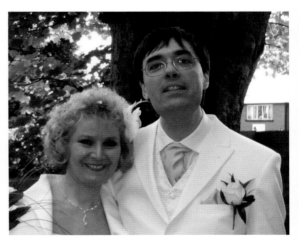

A head and shoulders photograph of the bride and groom – a must-have shot at any wedding. Photographed in the shade on a sunny day. PROGRAMME, F/4.0 AT 1/100 SEC, ISO 100, HANDHELD CAMERA

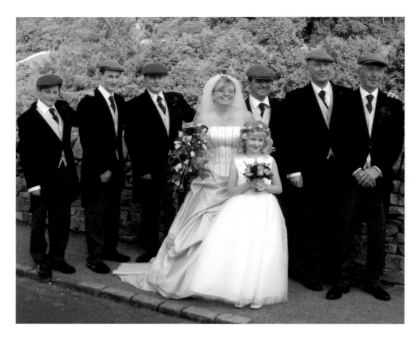

The Yorkshire flat-cap gang. A different, humorous shot. PROGRAMME, F/7.1 AT 1/250 SEC, ISO 200 WITH FLASH, HANDHELD CAMERA

Reception

There are plenty of good photo opportunities at the reception; the main ones are of the bridal pair welcoming the guests, cutting the cake and the formal speeches.

Welcoming the guests is quite straightforward, the only problem being stray heads partly obscuring the happy couple. Cutting the cake is usually announced, with photographers invited to take photographs. Arrange yourself so that the bride, groom and cake are the same distance from the camera and therefore all in focus. Concentrate on the composition, not allowing the groom to be blocked by the bride.

Photographing the formal speech makers is important because the official photographer may have already left the premises. Try to be as inconspicuous as possible, shooting from a crouching position so as not to block the view. The camera settings mentioned earlier with the flash switched on would be fine.

Capturing the throwing of confetti or rose petals after the ceremony or reception, and the final departure of the couple at the end of the day could provide two further photo opportunities. By this time you should have an excellent set of images, capturing the essence of this very special day. They should be ones that the bride and groom in particular, will be thrilled to see. And it can all be achieved using a point-and-shoot compact digital camera.

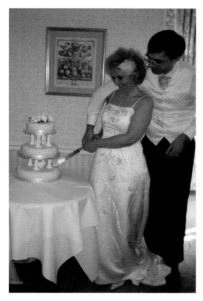

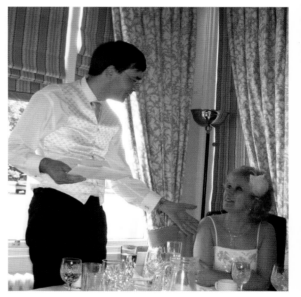

Cutting the cake. Two shots were taken: one of the couple looking at the camera and this one, which I prefer, as the couple look as if they are doing something important.
PROGRAMME, F/2.8 AT 1/60 SEC, ISO 100 WITH FLASH, HANDHELD CAMERA

The groom gestures to his new bride during his traditional speech. 'Grab' shot with no time to think about settings or focusing – but the camera did well.
PROGRAMME, F/3.2 AT 1/100 SEC, ISO 100, NO FLASH, HANDHELD CAMERA

HOLIDAYS

BEFORE GETTING DOWN to some serious thinking about the camera and what accessories to pack, take a good look at last year's photographs. Why do they look so ordinary or maybe even boring? Finding yourself in a new, exciting holiday environment, where everything looked different and attractive, you probably used your camera like a machine gun, photographing everything in sight, without giving much thought or time as to why you were taking the photographs. This time though, things will be different.

It would be very beneficial to find out something about your holiday destination before you set off. Buy a guidebook, check on special events, annual celebrations, interesting locations and chat to friends and colleagues who have visited the area, for their choice of the best vistas and sites to photograph.

Accessories Unearth the camera, insert a charged battery, check the memory card is in the camera, and take a few shots to re-familiarize yourself with the basic functions. Don't feel embarrassed if this means referring to the camera user manual. In addition to your camera, what accessories you take will depend on whether this is simply a family holiday with a few snapshots for the album, or a more serious photographic holiday with the family in tow. Whichever category your holiday comes into, you will need a spare charged battery or two, a mains charger, if possible, and a spare memory card (256 and 512MB have reasonable capacities).

The choice of camera support is a difficult one. A conventional tripod would be ideal but if this is to be a family holiday, the tripod could be a non-starter. You could use a small monopod with a ball and socket head, which can also be used as a walking stick. Failing that, what about a table-clamp tripod? Using the self-timer you can include yourself in a family photograph. Some photographers use a small beanbag, which also protects the camera base when used on rough surfaces.

Another accessory worth thinking about is a screen shade (see page 35). Viewing the screen in bright sunlight can be a problem, partially solved by using a pop-up shade attached to the screen.

All compact camera cases include a substantial loop allowing the case to be slipped onto a belt. This can be very useful because it leaves the hands and shoulder free.

Filters

A polarizing filter will enhance blue sky, reduce surface reflections and produce more saturated colours. A uv filter will cut out some of the blue light at high altitudes. A graduated neutral density filter is used to reduce the contrast between sky and ground without affecting the overall colour. Certain scenes will sometimes benefit from a warm-up filter, or a sunset or starburst filter.

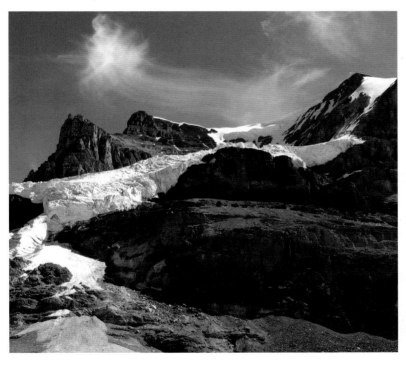

The Athabasca glacier in Canada. A polarizing filter was used to deepen the blue sky and reduce some of the surface reflections. PROGRAMME, F/8 AT 1/500 SEC, ISO 100, TRIPOD.

On holiday I do not suggest rushing out to take photographs as soon as you arrive, but do have a leisurely stroll around the area, giving yourself time to relax and recover from the journey. Look at a few postcards, as they always show some of the best views; try working out where and at what time of day they were taken. Finally, buy a local map.

COMPOSITION

If you want to include someone as part of an attractive scene, try to integrate them into the picture by positioning them towards the side of the frame, with them looking not at the camera, but across into the view. Try to avoid the obvious pitfalls; sloping horizons, tilting buildings in the background, chopped off feet, or water gushing out of someone's head as they stand directly in front of that classical fountain. This scene may look quite natural at the time because with two eyes we see things in three dimensions and with depth, but a flat, two-dimensional photograph, which does not show depth, can result in a rather comical image.

Rialto Bridge, Venice, Italy. The bridge is carefully positioned in the visually strong upper third of the frame. The eye then follows the gondolas to the centre of the frame and up to the bridge.
PROGRAMME, F/5.6 AT 1/400 SEC, ISO 80, HANDHELD CAMERA.

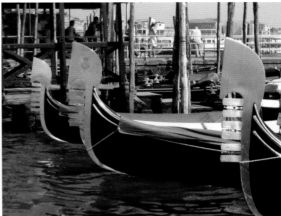

Bridge of Sighs, Venice, Italy. This picture illustrates a common fault – tilting verticals. PROGRAMME, F/3.5 AT 1/320 SEC, ISO 80, HANDHELD CAMERA.

The background is in the upper third of the picture. The eye moves from one decorated prow to the next, traversing the whole image. PROGRAMME, F/4.5 AT 1/500 SEC, ISO 80, HANDHELD CAMERA.

CAMERA SETTINGS

What would be appropriate camera settings? The programme mode with a low ISO setting would be fine. If you have a choice of settings use a large lens aperture for a close-up of head and shoulders to throw the background out of focus, but stop down the lens if the shot also includes an expansive view in addition to the person. Again use the lowest ISO setting possible.

OUT AND ABOUT

On holiday in the Italian lakes, my wife and I booked a day trip to Venice. I knew exactly what I wanted to photograph and planned the visit accordingly. I used the programme setting at ISO 80, and handheld the camera as the light level was incredibly high, prompting the camera to select a very short shutter speed. The image on the LCD screen was almost impossible to see so I used the eye-level optical viewfinder for most of the shots, compensating for the inaccurate field coverage.

A children's holiday heaven – a rocky shore on a bright day. A natural happy shot. PROGRAMME, F/5.6 AT 1/150 SEC, ISO 100, HANDHELD CAMERA.

Children on holiday

If you are holidaying in the sun with high light levels, handholding the camera is satisfactory. Shooting in the sun will produce very high-contrast images, though a little forced flash will help to lighten the inevitably dark shadows. Photographing in the shade is ideal, but children seem to automatically migrate into the sun.

For beach photography the auto or programme settings are fine. A beach setting will select a short shutter speed with the appropriate lens aperture, plus forced flash.

Early morning mist as seen from the summit of Mount Baldo, Italy. Thanks to the mist, the distant mountain tops are much paler than the foreground, giving an impression of distance and depth. PROGRAMME, F/8 AT 1/500 SEC, ISO 100, HANDHELD CAMERA.

If you are in your holiday area for a few days you can decide which *Landscapes* part of the day would provide the most appropriate lighting. Many landscape photographers prefer the early morning and late evening light, when the rising and setting sun can add extra drama to a picture. Backlighting is good for highlighting delicate structures and for putting sparkle on the water, while side-lighting will enhance surface texture, emphasizing undulations in the landscape. Frontal lighting is a very safe form of illumination, with everything facing the camera adequately lit, but the results tend to be rather flat.

If you set the camera on night scenes it will automatically select a *Night scenes* wide lens aperture and the highest ISO setting (see page 102 for more on photography at night). As it is not possible to hold the camera steady for 1/6–1 sec, brace it against any solid surface such as a lamp post. If you have a tripod or a table-clamp tripod to stabilize the camera, a much sharper (less 'noisy') image can be obtained using the 'programme' setting and a lower ISO setting such as 100–200 (instead of the ISO 1600–3200 that the camera would automatically set using a night-scene option).

Night scene in Malcesine harbour, Italy. Handheld camera braced against lamp post. The programme setting and a lowish ISO of 200 produced a smoother, sharper image.
PROGRAMME, F/8 AT 1/500 SEC, ISO 200, HANDHELD CAMERA.

GLOSSARY

Adobe Photoshop The most widely-used image-editing software program.

Ambient light The background light in a scene before extra lighting is added.

Aperture The lens aperture controls the amount of light passing through the lens to the image sensor.

Aperture priority Allows you to choose an appropriate lens aperture while the camera selects the shutter speed.

Artefact A visible blemish in a digital image.

Aspect ratio The ratio of the width to height of an image, screen, page or picture.

Autofocus The camera's system of automatically focusing the image.

Backlight Light falling on the back of the subject and onto the front of the camera.

Bracketing Taking a series of frames (usually three) of the same scene, at different exposures.

Burst rate The speed at which the camera can process image data to the memory card and be ready to capture the next shot.

Card reader A device used to transfer data from a camera memory card into the computer.

CCD (charge-coupled device) A type of image sensor.

CF card Compact Flash memory card.

CMOS (complementary metal-oxide semi conductor) A high-quality image sensor.

Colour temperature A measurement of light colour expressed on the Kelvin (K) scale.

Compression Technique for reducing the size of a digital file by removing redundant data.

Contrast The range between the highlight and shadow parts of an image, or the difference in illumination between colours or adjacent areas.

Dedicated flash The camera assesses the amount of light required, adjusting the flash output accordingly.

Depth of field The amount of the image that is acceptably sharp. Depth of field extends one third in front of and two thirds behind the point of focus.

Dpi (dots per inch) A measure of the resolution of a printed image. The more dots per inch, the higher the resolution.

Dynamic range The range of tones, from the brightest to the darkest, which can be captured by an imaging sensor.

Exposure The amount of light that falls on the image sensor; a combination of the lens aperture and the shutter speed.

Exposure compensation Camera function that allows adjustment of the exposure relative to the recommended camera setting.

F-number Also known as f-stop. Denotes the size of the lens aperture in relation to the focal length of the lens.

Focal length The distance between the optical centre of the lens and the image sensor, when the lens is focused at infinity.

Focus lock A mechanism that locks autofocus so that the scene can be recomposed.

Gigabyte (GB) A unit of computer memory equal to 1,024 megabytes.

High key Photographs where most of the tones are taken from the light end of the scale. Used in portraits.

Histogram A graphic representation of the tonal range of an image with underexposure on the left and overexposure on the right. The vertical axis indicates the number of pixels involved.

Hot shoe An accessory on the more expensive digital cameras that is used to house and control an additional flash unit.

Interpolation Enlarging a digital image by introducing new pixels. Interpolated images rarely have the same definition as the original non-interpolated image.

ISO (International Standards Organization) The standard measure for film sensitivity.

Jaggies The jagged edge produced by individual pixels in a low resolution image.

JPEG (Joint Photographic Experts' Group) A standard compressed image file.

Lossy Type of file compression, such as JPEG, that involves loss of some data and slightly reduced image quality.

Macro A special setting for taking close-up photographs.

Megabyte (MB) A unit of computer memory. One megabyte is equivalent to 1024 kilobytes or 1,048,576 bytes.

Megapixels One million pixels equals one megapixel.

Memory card Removable storage card for digital cameras.

Microdrive Miniature hard disk, built into a memory card, with a large storage capacity.

Multi-segment metering Meter readings taken from different segments of the frame, with more complex systems producing better exposures. This is the default setting for most cameras.

Noise A grainy appearance that increases at high ISO settings.

Overexposure When too much light falls on the image sensor, resulting in a pale, washed-out image.

Parallax The difference between what the camera eye-level viewfinder sees and what the camera lens sees. Can be very pronounced in close-up work.

Pixel Abbreviation of 'Picture element'. Pixels are the smallest units of a digital image; together they make up a bitmapped picture.

Polarizing filter A filter that darkens blue sky and reduces reflections on water and shiny, non-metallic surfaces.

RAW A format that uses no compression and produces the highest quality images.

Resolution The quality of an image measured in pixels: the higher the resolution, the better the image quality.

RGB (red, green and blue) Colours that make up the pixel grid on the image sensor.

SD card A type of memory card used in a wide range of digital cameras.

Shutter The mechanism that controls the amount of light reaching the sensor by opening and closing when the shutter release is activated.

Slave unit A device that triggers a flash unit using the flash from another unit (often the one built into the camera).

Snoot A cone-shaped attachment that enables a beam of light to be concentrated into a small circle.

Spot metering A metering mode that measures the light from a very small part of the frame.

Teleconverter An optical device that on digital compacts screws onto a tube at the far end of the lens, increasing the effective focal length.

TIFF (Tagged-Image File Format) A file format that uses lossless compression to produce high-resolution digital images. Not available on digital compacts.

Underexposure A condition in which too little light reaches the sensor. There is too much detail lost in the areas of shadow in the exposure.

USB (universal serial bus) Standard connector for attaching peripherals to a computer, enabling fast transfer of digital information.

Viewfinder An optical system used for composing and sometimes focusing the subject.

White balance A function that allows the correct colour balance to be recorded for any given lighting situation.

Zoom A camera lens with a variable focal length, producing an increasingly larger image.

ABOUT THE AUTHOR

Arnold Wilson, a professional biologist, has spent his working life in teaching and lecturing. Photography has been his lifelong interest and, over the years, he has contributed to most of the current photographic magazines and has written four books.

His work has been exhibited both in the UK and abroad. He was an early overall winner of the prestigious Wildlife Photographer of the Year competition and in September 2000, Arnold was judged overall winner of the BBC Countryfile Photographer of the Year competition with a close-up photograph of a bumblebee in free flight. Having taken early retirement, Arnold Wilson now spends most of his leisure time photographing people and places, but his special interest is still nature photography.

ACKNOWLEDGEMENTS

My special thanks to James Beattie at PIP, for not only affording me the opportunity of writing this book, but for giving valuable assistance in the early part of its preparation. My very special thanks to Rachel Netherwood, Project Editor, who gave helpful advice and valuable assistance throughout the preparation of this book, and to all at PIP who designed the book and provided the studio images, converting my manuscript and folders of images into an attractive and well-balanced book.

On the 'home front' I wish to thank Jan and Mike Kelly, my computer consultants, who on several occasions sorted out a wayward computer. A big thank you also to my family, Carol, Ian, Isabel, Daniel, Gabriella and Paul, for providing some of the photographs and willingly posing for others.

Finally a very special thank you to my wife Margaret, who not only encouraged me throughout the project, but also helped to sort out the computer images and convert my much-altered, hand-written work into a beautifully presented manuscript, correcting a few errors on the way. To all I say a very grateful 'thank you', I could not have done it without your help.

INDEX

Contact us for a complete catalogue or visit our website.
PIP, Castle Place, 166 High Street, Lewes, East Sussex
BN7 1XU, United Kingdom
Tel: 01273 488005 Fax: 01273 402866
www.pipress.com